GERMAN MODERN

STEVEN HELLER

GRAPHIC DESIGN FROM

GERMAN

CHRONICLE BOOKS

& L O U I S E F I L I

MODERN

W I L H E L M T O W E I M A R

S A N F R A N C I S C O

The authors are indebted to Bill LeBlond, our editor at Chronicle Books, for his faith in this series over the past five years. Thanks to Mary Jane Callister at Louise Fili Ltd. for her design and production expertise. Further thanks go to Alan E. Rapp, assistant editor, Julia Flagg, design coordinator, and Michael Carabetta, creative director, at Chronicle Books for their support and hard work. And a tip of the hat to Sarah Jane Freymann, our agent.

Various people assisted in obtaining the materials for this book. We owe a great deal to James Fraser, librarian, Fairleigh Dickinson Library; Helga Krempke, Catherine Bürer, Barbar Meili, and Kurt Thaler at Museum für Gestaltung Zürich and Kunstgewerbemuseum Zürich, Switzerland; Kathy Leff at the Wolfsonian Museum, Miami, Florida; George Theophiles, Miscellaneous Man, New Freedom, Pennsylvania; and Irving Oaklander, Oaklander Books, New York City. Additional thanks to Karl Bernhard, Elaine Lustig Cohen, Mirko Ilić, Steven Guarnaccia, Eric Baker and Erik Spiekermann.

CREDITS

Unless indicated all materials in this book come from private collections: Kunstgewerbemuseum Zürich: 24 (top), 25, 40 (top), 41, 43, 46, 47 (top right and left), 50 (top middle), 53, 54, 55, 57, 58, 59, 60, 61, 62, 66, 68, 69 (right), 73, 74, 78 (right), 82, 87; Wolfsonian Foundation: 23, 30, 63; Ex Libris: 86 (bottom).

Book design by Louise Fili and Mary Jane Callister.

Library of Congress Cataloging-in-Publication Data: Heller, Steven. German modern: graphic design from Wilhelm to Weimar / Steven Heller & Louise Fili. p. cm. Includes bibliographical references. ISBN 0-8118-1819-5 (pbk.) 1. Commercial art—Germany—History—20th century—Themes, motives. 2. Modernism (Art) Germany—Themes, motives. I. Fili, Louise. II. Title. NC998.6.G4H46 1998 741.6'0943'09041—dc21 98-13048 CIP. Printed in Hong Kong. Distributed in Canada by Raincoast Books, 8680 Cambie Street, Vancouver, British Columbia V6P 6M9 10 9 8 7 6 5 4 3 2 1 Chronicle Books, 85 Second Street, San Francisco, California 94105 www.chroniclebooks.com

England was the cradle of the Arts and Crafts movement. France was the birthplace of Art Nouveau. But Germany was the font of twentieth-century modern graphic design. German designers introduced simplicity and abstraction to *Gebrauchsgraphik* (commercial art), pioneered corporate identity, perfected *Marken* (trademarks), and founded design schools and movements that defined European design for the commercial age. German graphic design was a miscellany of intersecting ideas and styles influenced by the demands of industry and commerce. Under the rubric German Modern, numerous graphic styles comprised a national aesthetic.

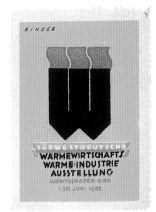

Modernism, a slippery term that denotes progressive twentieth-century art and design and was ultimately the umbrella term that covered the more mainstream Art Deco style, took hold in Germany in 1896 with the advent of *Jugendstil* (youth style). A Teutonic variation of French Art Nouveau, *Jugendstil* was a reaction to both the constraints of academicism and the excesses of ornamentalism. When it was introduced through progressive art and design journals such as *Jugend* (*Youth*) and *Simplicissimus*, as well as on the advertising posters then blossoming in the urban landscape, a new generation of artists expressed the zeitgeist through unprecedented graphics. This upstart "youth style" replaced stifling nineteenth-century Wilhelmian convention with color, geometry, and, most importantly, humor. Although *Jugendstil* was not quite as eccentric as its French and Belgian cousins—or as raucous as its Austrian sister, the Vienna Secession—it was a vibrantly illustrative and decorative style that altered the practice of applied art. Nevertheless, *Jugendstil* was but a bridge linking past and future.

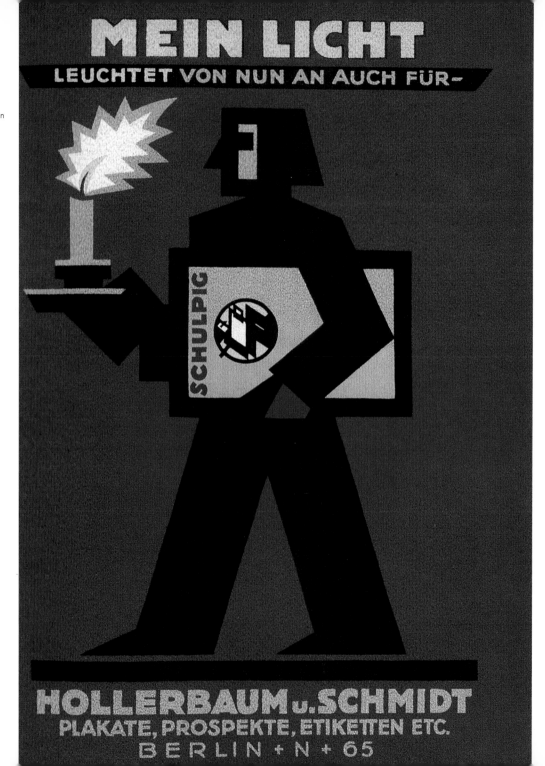

MEIN LICHT
LEUCHTET VON NUN AN AUCH FÜR—

SCHULPIG

HOLLERBAUM u. SCHMIDT
PLAKATE, PROSPEKTE, ETIKETTEN ETC.
BERLIN + N + 65

Within ten years of its inception, *Jugendstil* was decried as bourgeois, and its decorative veener was gradually stripped off everything from furniture to graphics. In graphic design, a new method called *Sachplakat* (object poster) emerged that redefined the term *modern* and transformed *Werbekunst* (pictorial advertising) from ornate to minimal. Superfluous matter was eschewed in favor of aesthetic economy. All that was shown was a graphic image of the essential object (or concept) being advertised, and usually a line or two of bold lettering.

The first *Sachplakat* was designed in 1906, the invention of a young graphic artist named Lucian Bernhard. He was frustrated with the fussiness of his own work, and in one piece, a maquette he planned to enter into a poster competition sponsored by the Preister match company, he painted out all the *Jugendstil* elements he had reflexively added. After removing every nonessential component (a cigar, an ashtray, a checkered table cloth, and a few requisite *Jugendstil* nymphs), all that remained were two red matches with yellow tips set against a dark maroon background with the word *Preister* in block letters at the top. It was uncommonly spare, yet curiously eye-catching. One of the competition judges, an advertising agent named Ernst Growald, was not only immediately attracted by it, he declared that it was a work of genius. By awarding Bernhard first prize, Growald launched the career of a leading poster artist, gave life to a poster movement, and initiated a graphic style that dominated German advertising for the next decade.

Sachplakat was principally practiced by the Berliner Plakat, a group of kindred artists and designers represented by Growald's Berlin-based printing firm and advertising agency, Hollerbaum and Schmidt. Through posters that heroized the mundane, the consumer's attention was directed to unambiguous graphic images of commerce and industry—a typewriter, a pair of shoes, a spark plug, a lightbulb, an engine, matches. The rejection of artifice was consistent with German industry's desire to infiltrate the mass consciousness through

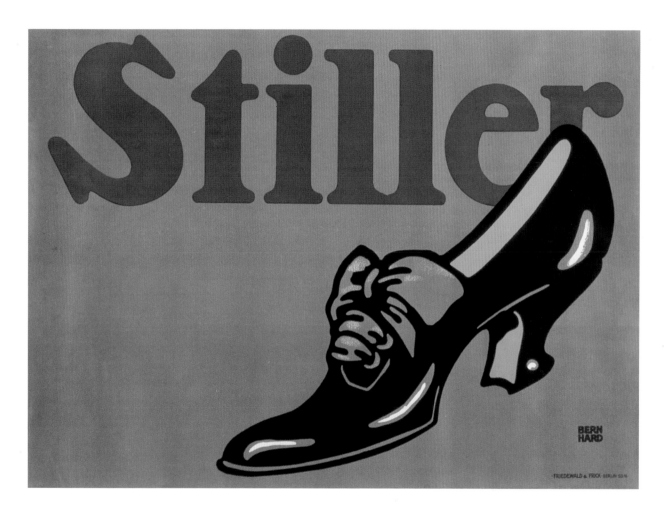

STILLER
Poster, 1908
Designer: Lucian Bernhard

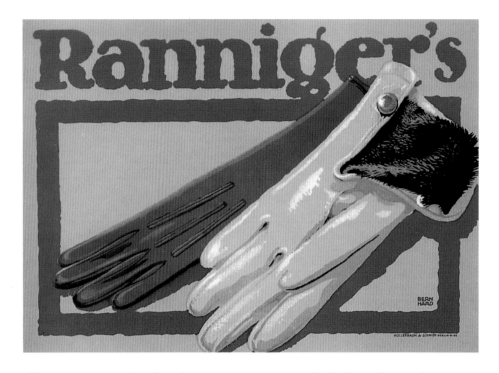

increasingly more effective means. Artifice-laden posters along Berlin's wide boulevards were harder to read from fast-moving cars and buses. The demands of the urban environment required simplicity.

Sachplakat prefigured the strategy currently known as branding, where a focus on mnemonic attributes of a particular product or service is key to consumer recognition, but with the emphasis so placed, German designers were required to make the objects that were to be promoted look even better than they were. Fresh new tins, cartons, boxes, and bottles were designed by many of the *Sachplakat* artists, yet the poster was still the most important selling tool. And *Das Plakat* (1910–21), Germany's most influential advertising and poster journal (which had a respectable circulation abroad) promoted the virtues of *Sachplakat* and celebrated its artists.

Edited by Hans Sachs, a Berlin dentist and president of the Friends of the Poster Society, *Das Plakat*

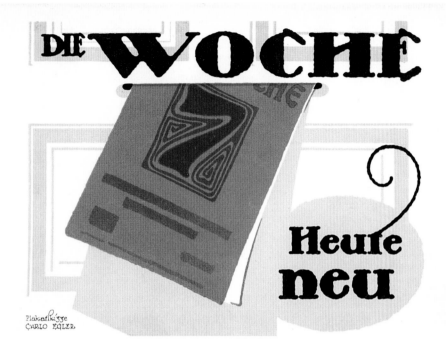

DIE WOCHE
Poster, c. 1908
Designer: Carlo Egler

attempted to wed business and art in a common cause. Its success was quantifiable. An overwhelming number of German retailers and manufacturers in the chemical, cigarette, and luxury foods industries employed posters and collateral print material to promote their respective wares. Similarly, the German Werkbund, an organization established to promote the production and sale of superior German goods internationally, propelled the applied arts—graphic design included—into the mass marketplace. From 1906 to 1914, posters advertising the bounty of these consumer goods spread the message faster and further than any other means.

Like *Jugendstil,* however, *Sachplakat* ultimately lost its novelty as repetition and mimicry reduced its commercial effectiveness over time. When *Sachplakat* no longer did its job, it gave way to what was more generally referred to as *Plakatstil* (poster style), an approach that offered a wider variety of images and methods. At this time a new graphic tool was also invented; a comic trade character embodying the

attributes of companies and products that historian Virginia Smith calls "the funny little man." In her book *The Funny Little Man*, Smith explains that, around 1912, *Werbekunst* went in two directions. One approach was humorous and featured the stylized little character introduced by Valentin Zietara and members of the Munich Six advertising group. The other approach created the "gloriously perfect figure," a heroically realistic portrait of a man or woman found in posters by Ludwig Hohlewin, who later in the 1930s developed a poster image of the "quintessential Aryan."

Comic mascots bestowed personality traits on mundane, inanimate products that were more or less indistinguishable from the competition. They possessed mnemonic power—the ability to infiltrate the consumers' conscious and subconscious. The perfect figure, on the other hand, was the model of German perfection, a high ideal that the average consumer might rise to simply by buying and using the advertised product. The widespread use of these two approaches marked the dubious beginning of an era when theories of *Reklame* (advertising) were prevalent throughout the German advertising industry. The individual artist's intuition and talent, which had heretofore been the guiding factors behind most advertising, were quickly subsumed by psychological theories wed to the pseudoscience of propaganda.

By 1914, German advertising was highly sophisticated in Berlin, Munich, Stuttgart, and Leipzig, where an annual advertising exposition was held; but with the advent of World War I, everything came to an abrupt halt. Production of most nonessential consumer goods was significantly reduced, and *Gebrauchsgraphikers* (commercial artists) had little choice but to give their services to the nation. Wartime propaganda campaigns took precedence, and even oppositional satiric journals, notably *Simplicissimus*, became resolutely patriotic. Posters in the modern style were replaced both by a stylized realism that celebrated the state and by a grotesque fantasy that demonized the enemy. This was a critical period of German history and a time when

progress in graphic arts might have been totally stifled, yet surprisingly a few dissenting artists produced antiwar messages in a progressive idiom. German Expressionism was the vehicle for the opposition.

Expressionism began in 1905 as an aggressively modern form of graphics inspired by traditional African art. Intended as a pure approach to artistic expression, it was started by a group of idealistic young artists called Die Brücke (the Bridge) who believed art was curative. A second group, Der Blaue Reiter (the Blue Rider), founded in 1912, took Expressionist art further into the political realm and fought against materialism while promoting spirituality.

Before the war, the Expressionists' call for social change was expressed in metaphysical terms. After Germany's devastating and costly defeat, many Expressionists rallied to the left. They produced print propaganda that defined the revolutionary spirit of postwar Germany's Weimar Republic, which was founded in 1919 after the abdication of Kaiser Wilhelm II. Although commerce and revolution do not usually mix, aspects of Expressionism's surface style were adapted in postwar advertising to promote cultural events and consumer goods.

As such, Expressionism turned into another casualty in the quest for novelty. It was not an entirely effective commercial style, although it was widely applied to advertisements and posters for some leading companies, including AEG (page 20).

Once in the mainstream, however, Expressionism became the object of derision, particularly by German Dadaists, members of the antiart art movement that rejected even the slightest hint of bourgeois artifice. Expressionism ultimately devolved into pure formalism to such an extent that by 1933, even Nazi propaganda minister Josef Goebbels favored making Expressionism Germany's national style.

Founded in Berlin in 1918, German Dada borrowed techniques from advertising to propagate its own

cultural and political agendas. Dadaists promoted an anarchic typographic idiom as symbolic of the destruction of bourgeois values. Dada mirrored the crises within the Weimar Republic, which after World War I was struggling to bring democracy to a nation that had long lived under the iron fists of monarchs and the military. Through disruption of the status quo in art and design, Dadaists sought to change in culture what they were incapable of doing in the halls of government. They thus took to the streets with leaflets and newspapers that espoused Communist ideology and incorporated unconventional type and images to agitate among the masses. Whether Dada really had any effect on mainstream *Gebrauchsgraphik* is a subject for debate, but the movement did reflect a general rejection of antiquated design and had an influence on the New Typography, a modern method practiced by progressive designers who were taught at or influenced by the Bauhaus.

The Staatliches Bauhaus, founded in 1919 in Weimar, was a state-sponsored art and design school that, according to its founder Walter Gropius, was created "not to propagate any style, system, dogma, formula, or vogue, but simply to exert a revitalizing influence on design." The Bauhaus existed to prepare a generation of artists and artisans to deal with the demands of industrialization and its impact on society and culture, and Bauhaus typography and graphic design courses contributed to radical shifts in how *Reklame* was composed and styled. The Bauhaus's *Neue Typographie* (New Typography), startlingly austere for the time, was codified in 1925 by Jan Tschicold and characterized by a total lack of ornament, a rejection of drawn or painted illustrations in favor of photography, and a preference for asymmetrical layouts with gothic typefaces. Incorporating layout principles that emphasized clarity, dynamism, limited color (usually red and black), and photography—traits found in Dutch de Stijl and Russian Constructivism—New Typography epitomized modernity.

The Bauhaus attempted to establish a universal design language that the mass population could easily

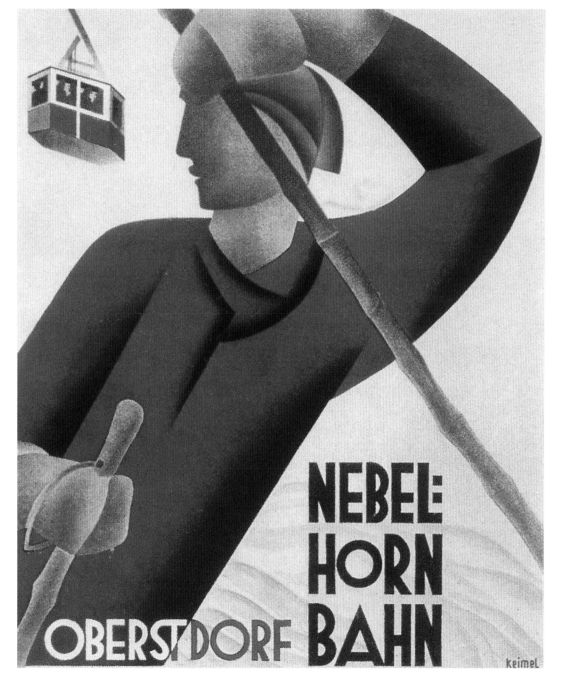

understand, but not every German appreciated the cool neutrality of modern design. What might be called orthodox modernism lacked the humor—and the human touch—that characterized both the best and worst of German *Reklamen*. The majority of German commercial artists were not slaves to dogma, but followed (or created) popular fashion. The words "'modern' and 'old-fashioned' have no real place in the vocabulary of advertising art," wrote an advertising critic of the day. "They pre-suppose a standard which for the advertiser has naturally and rightly no meaning." Depending on the client's needs and the artist's penchant, however, certain attributes of the New Typography—such as asymmetrical composition and sans-serif typefaces—were routinely incorporated with traditional illustrative and lettering approaches, which produced a hybrid modern style.

German modernism was a synthesis of contemporary design approaches. In addition to the New

Typography and *Plakatstil*, German designers subscribed to the international trend for *art moderne* decorative typefaces; yet there was always more difference than similarity between Germany and the rest of Europe. German commercial artists appeared to use more humor and were less likely to mimic the fine arts than those in other countries. German Modern was more hard-edged than the design idioms of France or Italy, for example, which had a softer, streamlined sensibility. While these and other industrial countries resolutely followed the *art moderne* style (later known as Art Deco) out of pride or happenstance, Germany set its own course. In Germany, the term *art moderne* was replaced by *Gebrauchsgraphik* to denote the general practice of commercial art. The magazine *Gebrauchsgraphik* (1924–41), founded by F. K. Frenzel, was Germany's premier advertising and commercial art trade journal. It published in English and German and respectfully showcased the best of international graphic design. Leading French, Italian, American, and Spanish artists were given exposure, but German ingenuity, rather than international stylistic conformity, was always celebrated.

Germany produced some of the most imaginative and creative commercial art during the post–World War I era, and many of its leading designers, contracted to work for businesses abroad, had great influence on the world of advertising and corporate identity. After the Nazis' rise to power in 1933, however, when the Dessau Bauhaus was closed (the school had moved from its original home in Weimar in 1925), it was forbidden to use modern design or sans-serif typefaces such as Futura, which Goebbels called a "Jewish invention." Rigid, central-balanced composition returned and traditional (and often illegible) Fraktur type was touted as symbolic of the glories of the nation. While the Nazi party did produce a graphic identity system and visual propaganda campaigns that were unmatched in history, overall German *Gebrauchsgraphik* was reduced to cliché. By the outbreak of World War II, whatever remained of German Modern was dead.

The world's most advanced machinery was developed in Germany during the first decades of the twentieth century. Likewise, the finest industrial advertising was produced there, too. It is a testament to German artistry that such mundane objects as gears, rods, pistons, and pipes could be rendered with such beauty and humor. In "Advertising German Machinery" (*Commercial Art 1927*), critic Walter F. Shubert wrote, "The most difficult problem of all [is] how to make an attractive design out of machinery and work tools.... No wild fancies or freedom of conception will avail anything in this particular branch, however; machines and tools demand the most intimate knowledge of their production, full comprehension of their usefulness, and a technical insight into their capacity." Although some artists could render every truthful detail of a turbo, contrary to the warning against fancies, Lucian Bernhard's poster for Hommel, a company that makes precision tools, employs such wit and humor that the ordinary is immediately transformed into the extraordinary (page 29). Other industrial products—lightbulbs for example—were afforded fetishist attention. Capturing the verisimilitude of a bulb's delicate shape and crystalline appearance challenged most artists. At the same time, the need to differentiate brands from one another forced artists to find novel methods of achieving perfection. Every medium from woodcut to oil paint was used to create an eye-catching look. Color played an important role in German commercial art in general, and industrial advertisements benefited from bright hues and loud splashes. Of course, the funny little man was recruited when the object alone did not exert enough personality.

**KÖLNER
MESSE**
Advertising
stamp, 1928
Designer
unknown

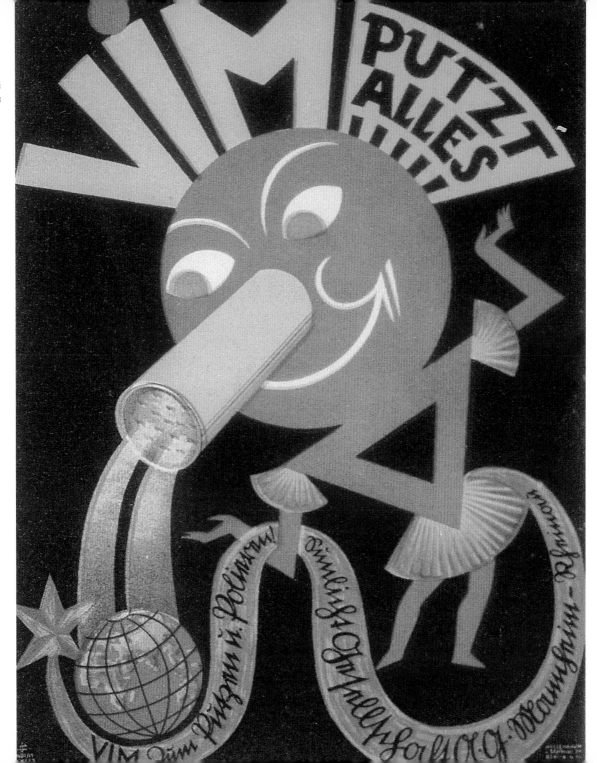

VIM
Poster, 1928
Designer:
Ludwig
Enders

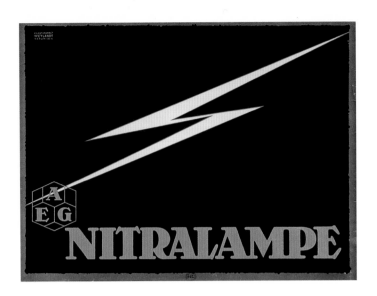

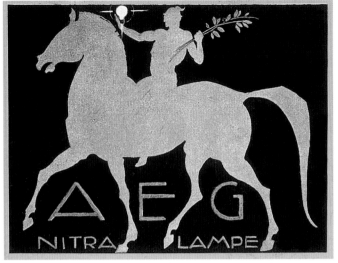

NITRALAMPE
Poster, c. 1925
Designer: Kunstanstalt
Weylandt

NITRALAMPE
Poster, c. 1925
Designer: Ludwig
Hohlwein

CUB-ARMATUREN
Advertising stamp,
c. 1923
Designer unknown

AEG
Advertising stamp,
c. 1923
Designer unknown

CH
Advertising stamp,
c. 1923
Designer unknown

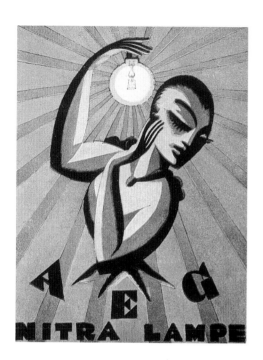

NITRALAMPE
Poster, c. 1925
Designer: Max
Schwarzer

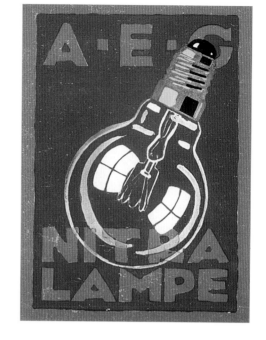

NITRALAMPE
Poster, c. 1925
Designer: Rudolf
Neubert

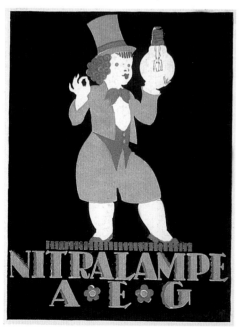

NITRALAMPE
Poster, c. 1925
Designer:
Valentin Zietara

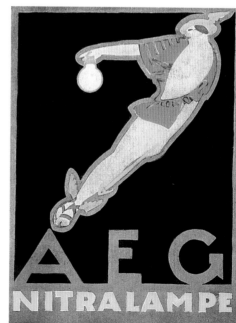

NITRALAMPE
Poster, c. 1925
Designer: Elizabeth
Von Sydow

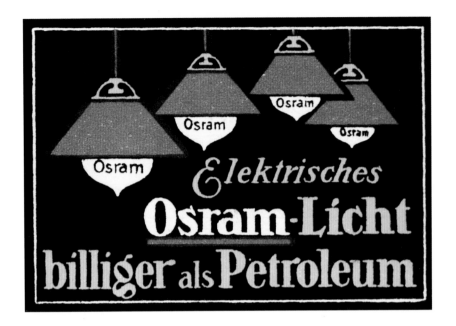

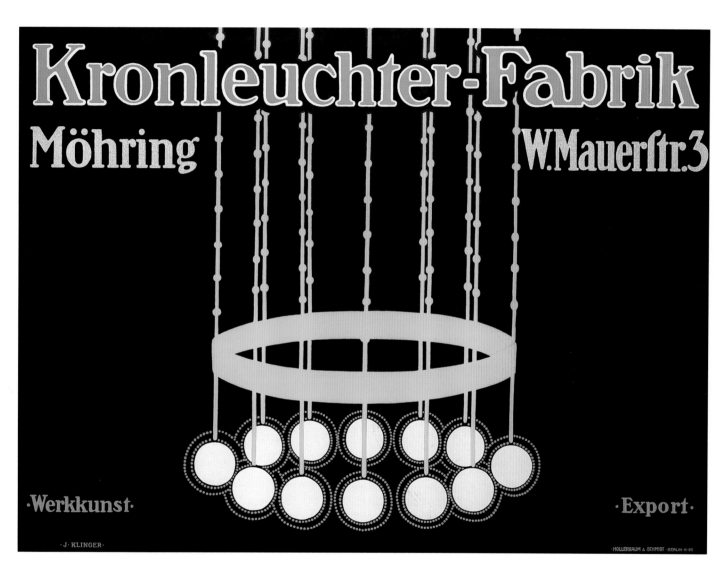

KRONLEUCHTER-
FABRIK
Poster, c. 1915
Designer: Julius Klinger

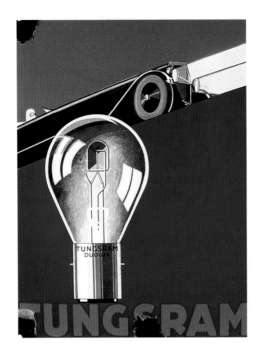

OSRAM

Poster, 1929

Designer: "N"

OSRAM NITRA

Poster, 1929

Designer unknown

TUNGSRAM

Enamel sign, 1928

Designer unknown

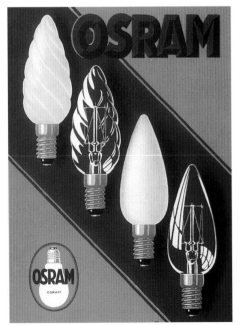

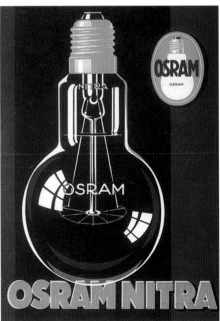

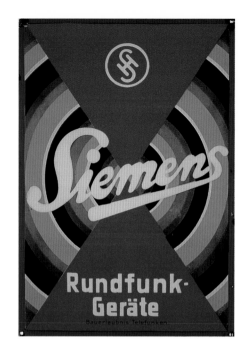

TELEFUNKEN
Enamel sign,
c. 1925
Designer unknown

SIEMENS
Enamel sign, c. 1925
Designer unknown

TELEFUNKEN
Enamel sign,
c. 1925
Designer unknown

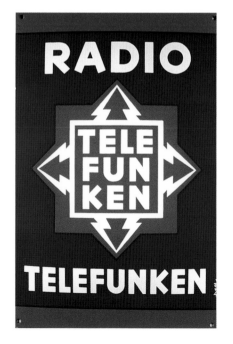

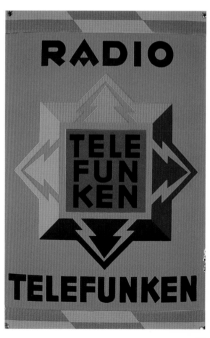

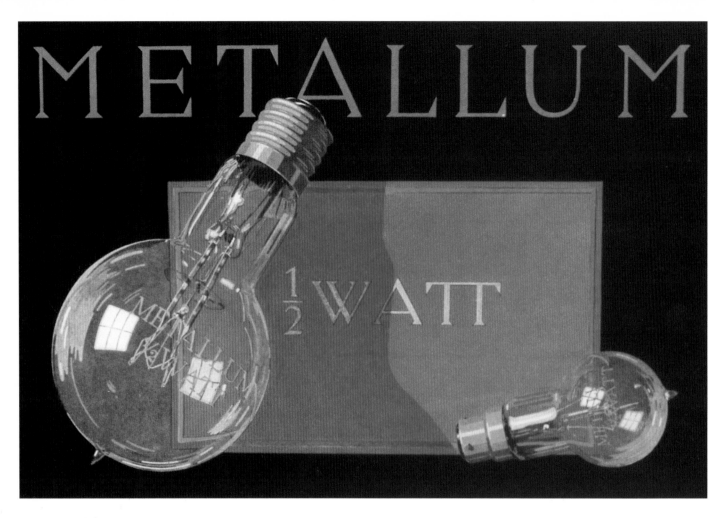

METALLUM
Poster, c. 1925
Designer: Willrab

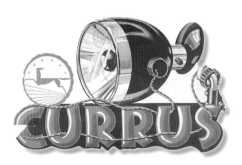

CURRUS
Point-of-purchase
display, c. 1928
Designer unknown

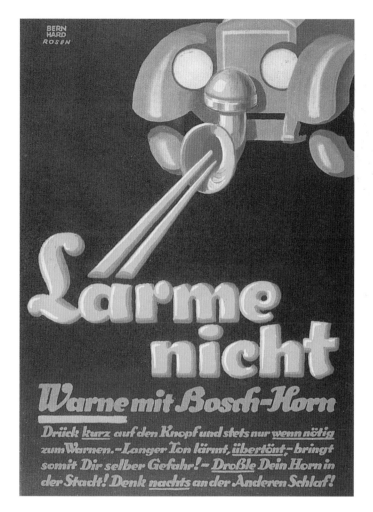

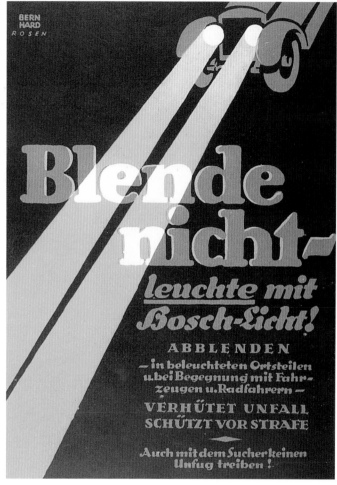

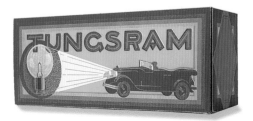

LARME NICHT
Poster, 1926
Designer: Lucian
Bernhard/Fritz Rosen

TUNGSRAM
Package, c. 1923
Designer unknown

BLENDE NICHT
Poster, 1926
Designer: Lucian
Bernhard/Fritz Rosen

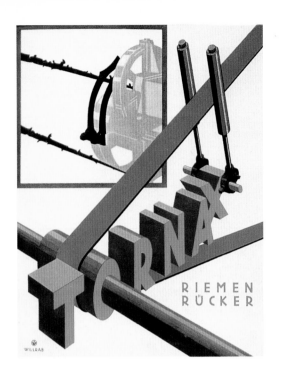

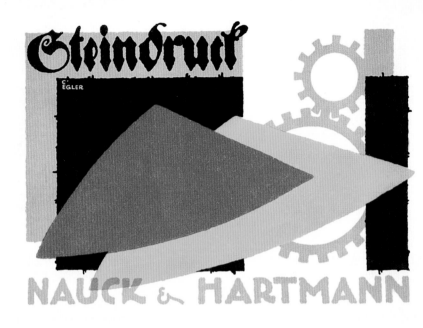

TORNAX
Poster, 1926
Designer: Willrab

**NAUCK &
HARTMANN**
Poster, c. 1912
Designer unknown

TON ZEMENT
Advertising
stamp, 1910
Designer unknown

**BEKLEIDUNGS
INDUSTRIE**
Advertising
stamp, 1925
Designer: Erik

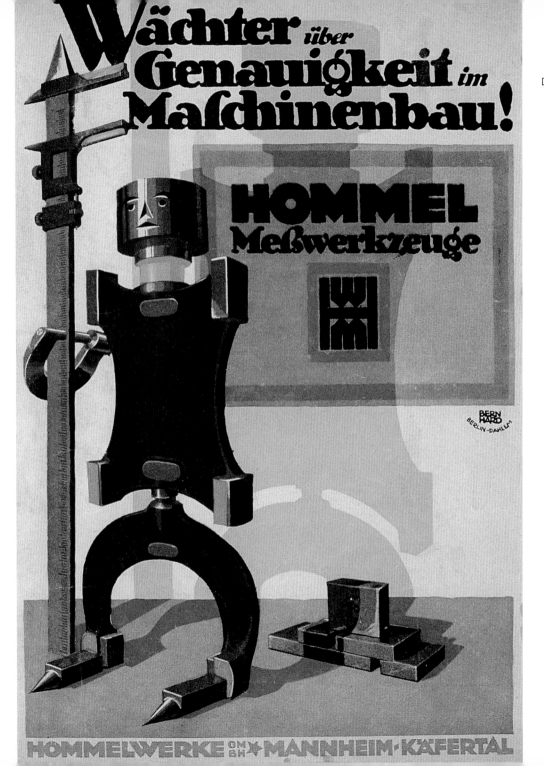

HOMMEL
Poster, c. 1912
Designer: Lucian
Bernhard

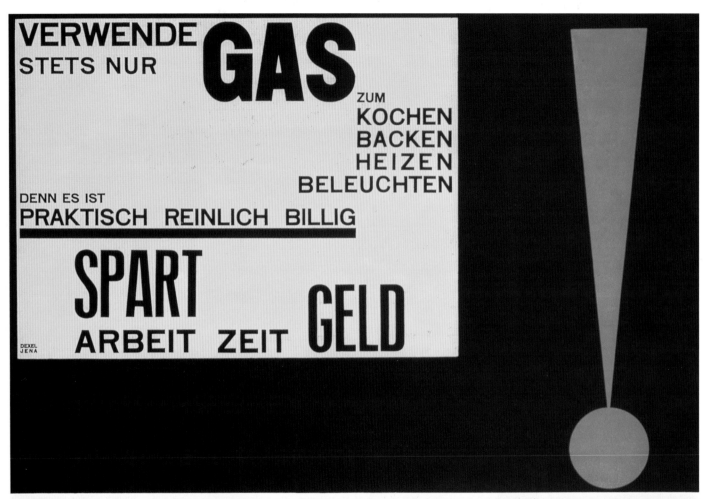

GAS
Poster, 1924
Designer: Walter Dexel

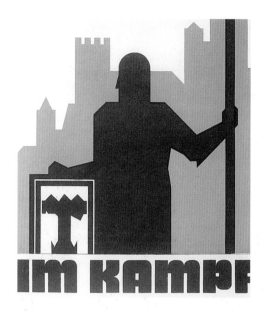

IM KAMPF
Advertisement,
1924
Designer unknown

GLAS
Advertisement, 1928
Designer: Karl
Schulpig

AN ALLE
Advertisement,
1924
Designer unknown

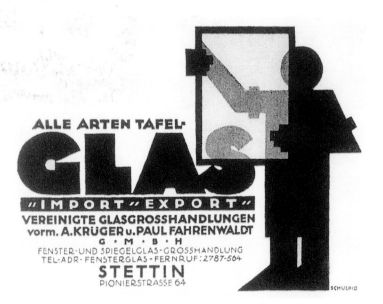

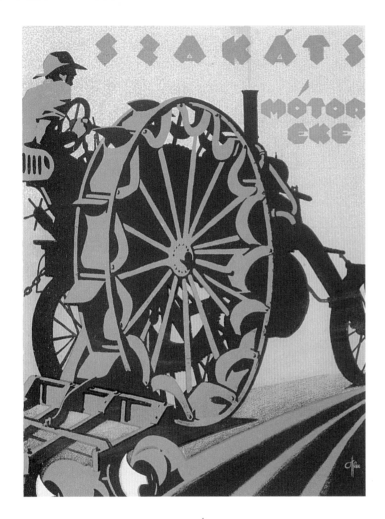

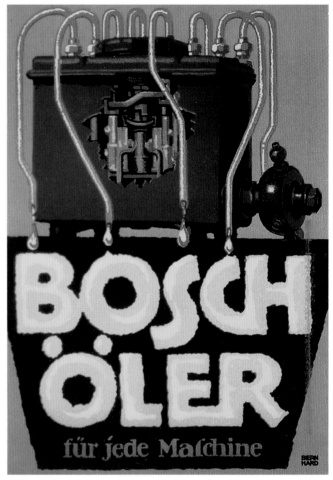

SZAKÁTS
Poster, c. 1920
Designer:
Otto Ottler

BOSCH ÖLER
Poster, c. 1914
Designer:
Lucian Bernhard

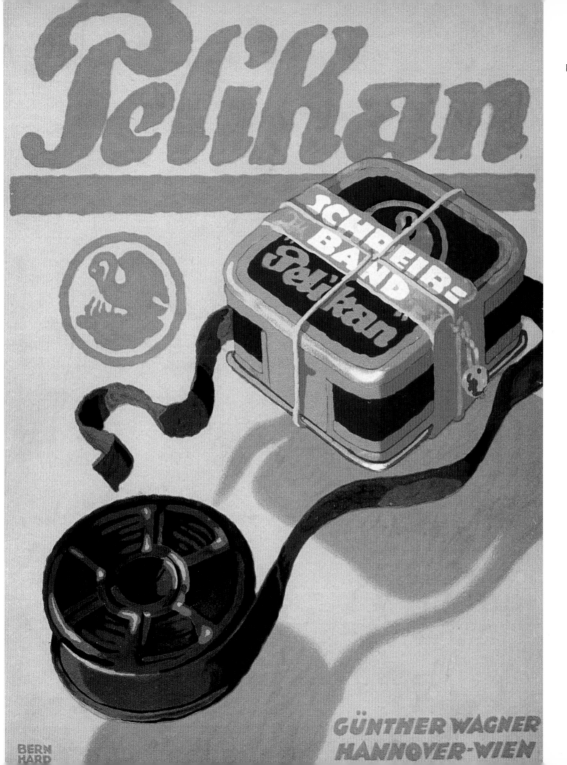

PELIKAN
Poster, 1920
Designer:
Lucian
Bernhard

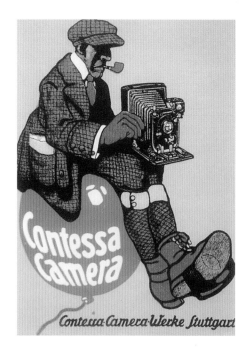

CONTESSA CAMERA
Poster, c. 1915
Designer: Propaganda
Stuttgart

DER NEUE BOSCH
MAGNET
Poster, c. 1915
Designer: Propaganda
Stuttgart

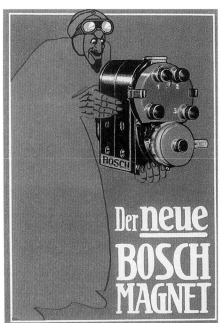

CONTINENTAL-
RADIATOREN
Poster, c. 1915
Designer: Propaganda
Stuttgart

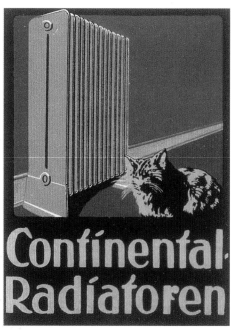

URDIKA
Poster, c. 1920
Designer: Fritz Julian

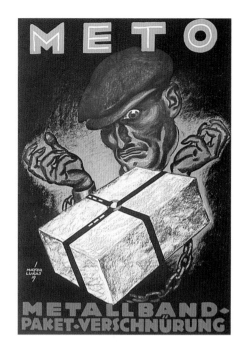

METO
Poster, 1919
Designer: Mayer-Lukas

GOLIATH
Poster, c. 1915
Designer: Propaganda
Stuttgart

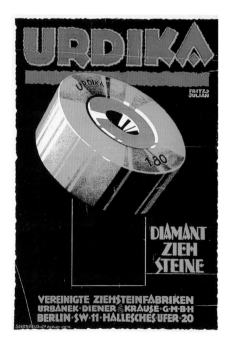

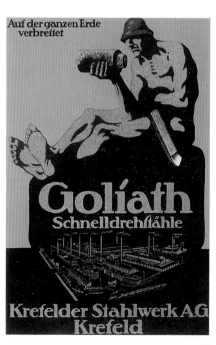

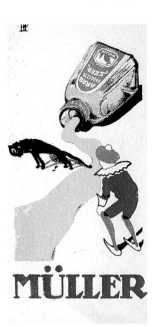

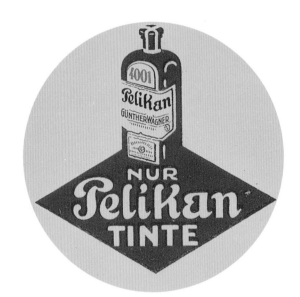

PELIKAN
Advertising
stamp, c. 1930
Designer unknown

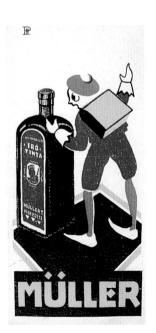

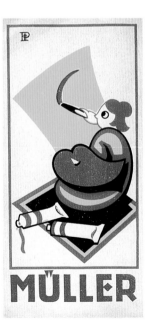

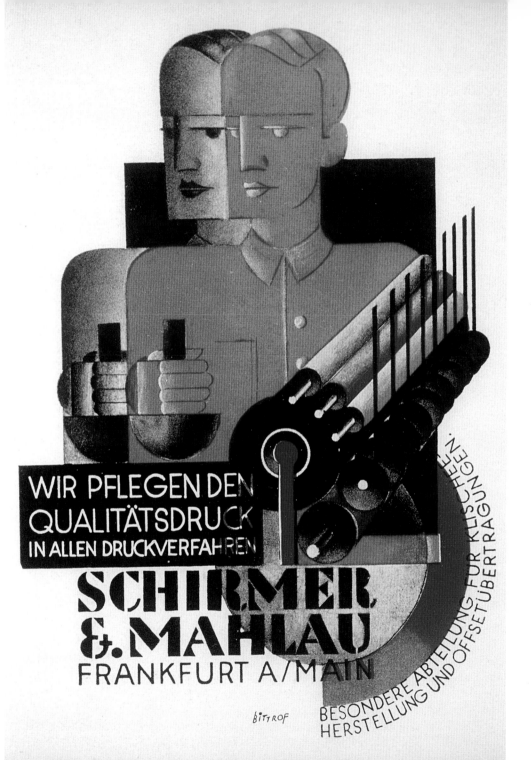

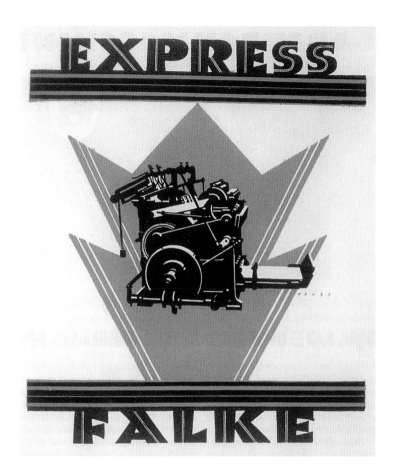

EXPRESS FALKE
Poster, c. 1920
Designer: Henze

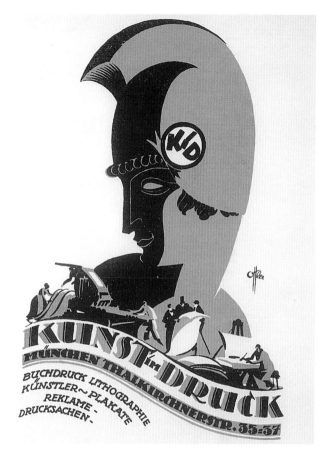

KUNST IM DRUCK
Poster, c. 1920
Designer: Otto Ottler

**LEIPZIGER
MESSE**
Poster, 1925
Designer: Baus

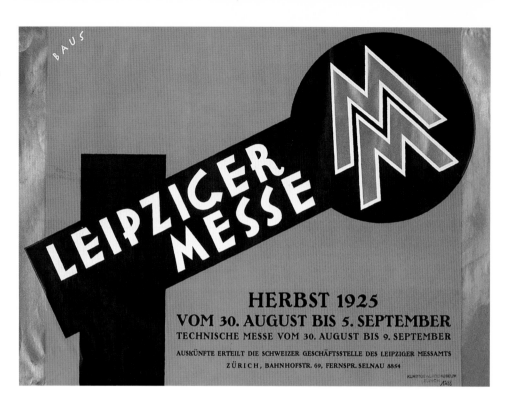

GRAZER MESSE
Advertising stamp,
1926
Designer unknown

BAFA
Advertising stamp,
c. 1930
Designer unknown

WALTER HELD
Advertising stamp,
c. 1910
Designer unknown

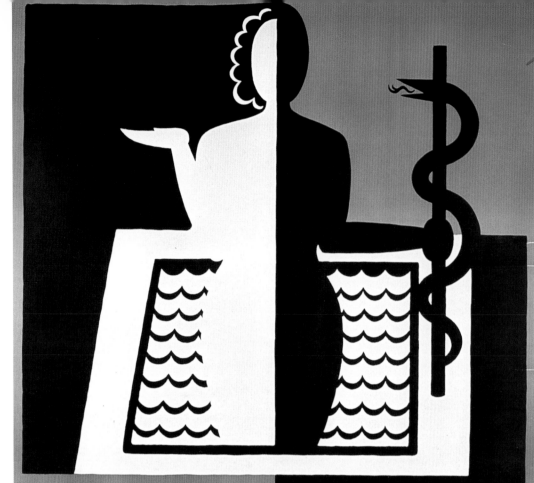

As capitals of commercial art, Berlin and Munich hotly competed with both Stuttgart and Leipzig, which were panting in second place. Berlin was home to Hollerbaum and Schmidt, Germany's foremost printer and the advertising agent for the Berliner Plakat. Munich produced Ludwig Hohlwein and "The Six," a highly successful confederation of Munich's other leading *Gebrauchsgraphikers*. While most commercial artists were generalists working for a variety of large and small companies and businesses, culture was the industry that pushed Berlin and Munich artists into the top of their profession. Huge quantities of advertising for film, theater, cabaret, and art exhibitions emanated from these two cities. Since many different talents were caught up in the cultural vortex, there was no single dominant style, although a fashion for *moderne* prevailed. In posters for films, for example, symbolism was applied for films in which establishing a sense of plot was more important than showcasing the actors; yet stylized realism was used when it was necessary to express the film's content literally. Photomontage, a modern graphic tool that was gaining adherents during the mid-1920s, was increasingly used and encouraged, particularly to advertise "noir" films with a modern sensibility. And photographs themselves replaced painted or illustrative art in design that incorporated the New Typography. Posters were the primary advertising medium, and pasting them on special kiosks was the primary means of dissemination. In addition, poster stamps—miniature versions of larger posters or original designs—were an important method of mass communication.

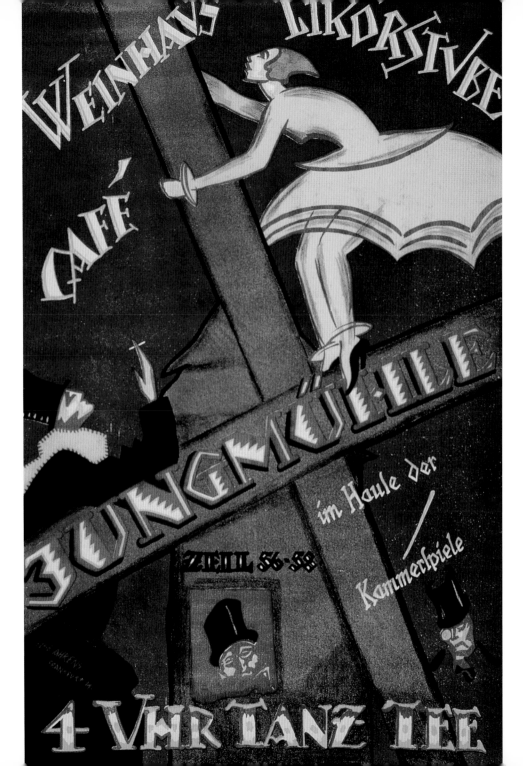

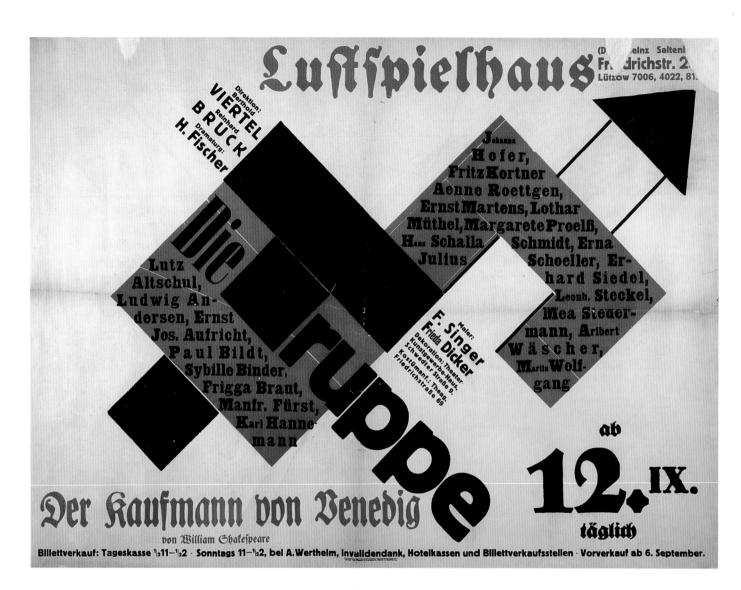

DIE TRUPPE
Poster, c. 1925
Designer unknown

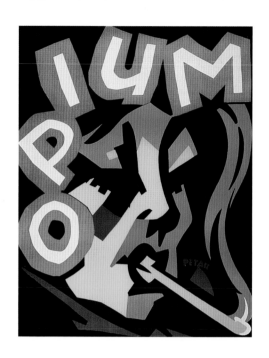

OPIUM
Poster, c. 1925
Designer: Petau

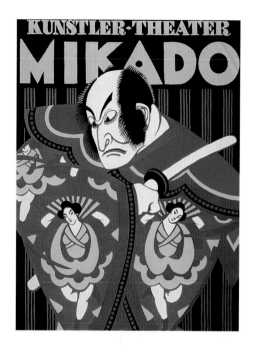

MIKADO
Poster, c. 1928
Designer:
M. Schwarzer

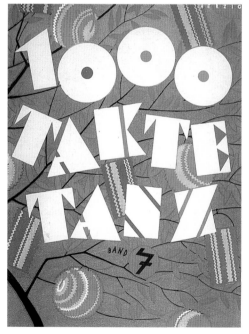

1000
TAKTE TANZ
Songbook cover,
c. 1930
Designer: Herzig

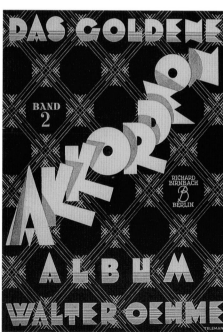

DAS GOLDENE
AKKORDEON ALBUM
Songbook cover,
c. 1930
Designer: Telemann

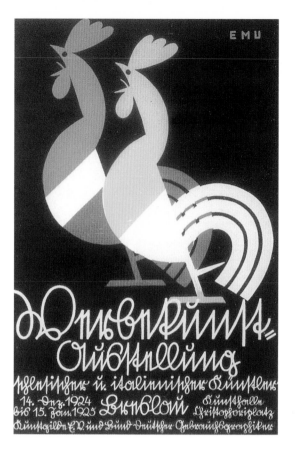

WERBEKUNST
AUSSTELLUNG
Poster, 1925
Designer: Erik Murcken

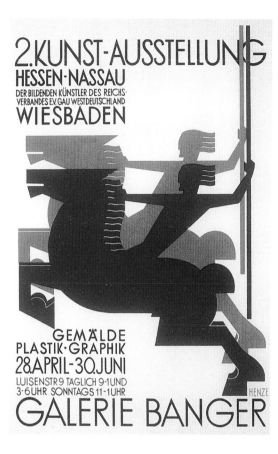

GALERIE BANGER
Poster, 1926
Designer: Max Henze

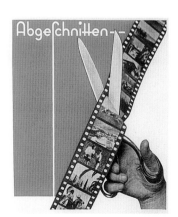

ABGESCHNITTEN
Advertisement, c. 1928
Designer: Werner Epstein

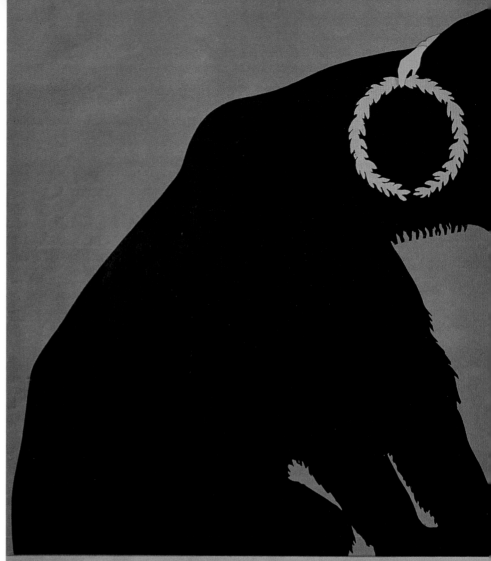

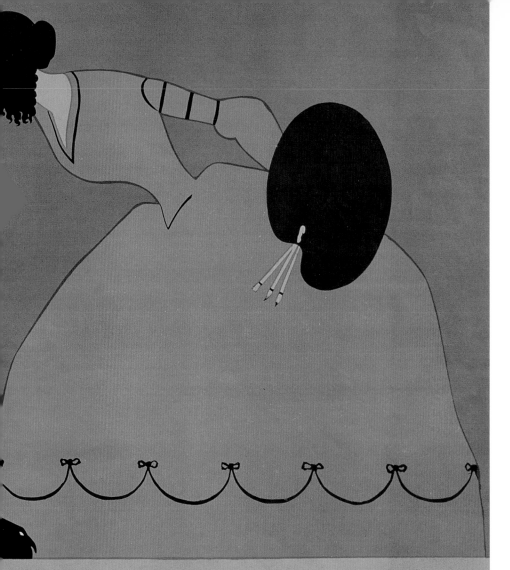

APRIL-AUGUST 1907
ECESSION
9 A.D. UHLANDSTRASSE
UHR EINTRITTSPREIS Mk.1

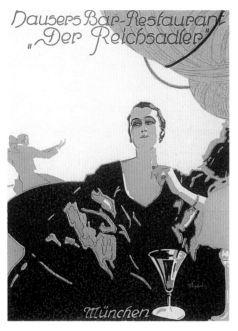

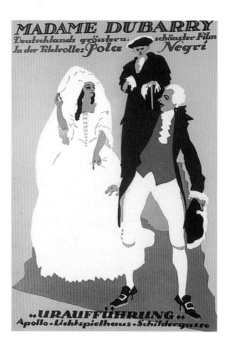

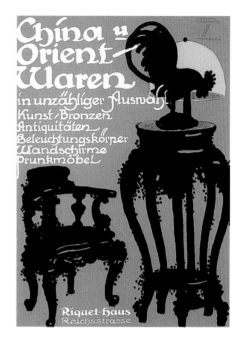

DER REICHSADLER
Poster, c. 1925
Designer: J. V. Engehard

MADAME DUBARRY
Poster, 1916
Designer: Mayer-Lukas

**CHINA UND
ORIENT WAREN**
Poster, c. 1912
Designer: Ludwig Hohlwein

**GROSSE INTERN
AUSSTELLUNG**
Advertising stamp, 1913
Designer unknown

**NURNBERGER
KUNSTGENOSSENSCHAFT**
Advertising stamp, c. 1923
Designer unknown

OSTMESSE
Advertising
stamp, 1937
Designer unknown

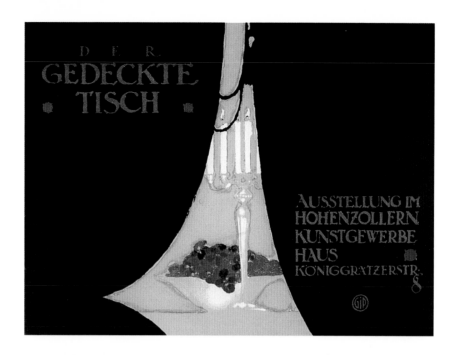

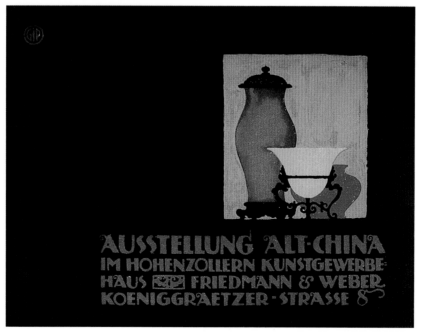

**DER GEDECKTE
TISCH**
Poster, c. 1913
Designer: Julius
Gipkens

**AUSSTELLUNG
ALT-CHINA**
Poster, c. 1913
Designer: Julius
Gipkens

By the late 1920s, people of means took the great ocean liners from Hamburg and Bremen to western and southern ports of call. Germany had been famous before the war for its tourist industry and was proud of its cruise lines—Hamburg-Amerika and Deutsche-Afrika, among them. After the wartime suspension, the ships were refitted for peacetime passage, and the industry boomed again. Travel posters were the most effective way of advertising both ships and exotic locales. As convention dictated, either the prow or the smokestacks of the mammoth steamers was the focal point for

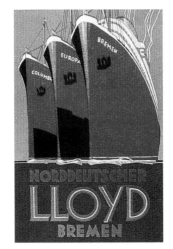

most posters. Alternatively, romantic vignettes of ideal destinations were common, and these posters became prized collectibles. Many of the posters were directed at German citizens traveling abroad, but others were made to entice foreign travelers to select the superior German lines. Ships were not the only point of pride, however; international air transport was just starting to become popular, particularly the Zeppelin fleet of lighter-than-air ships. Before the *autobahn* allowed for speedy vehicular travel throughout Germany, train service was the fastest and most common form of leisure transportation to points in and outside Germany. Posters advertising train travel to holiday resorts were hung in all the travel agencies and railroad stations. Their idealized, at times symbolic, representations of speeding locomotives instilled a sense of wanderlust and promoted an image of comfort. As beautiful as the posters in this genre may be, however, the artists were limited by various unmistakable clichés. The narrow glossary of repetitive graphic forms and themes shown in this section insured that the consumer would be indoctrinated in the joys of travel.

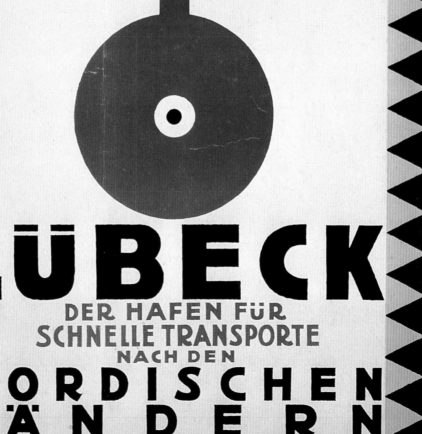

LÜBECK
DER HAFEN FÜR
SCHNELLE TRANSPORTE
NACH DEN
NORDISCHEN
LÄNDERN

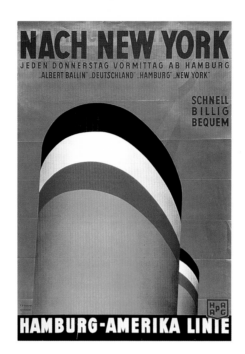

NACH NEW YORK
Poster, c. 1930
Designer: Etbauer

KANARISCHEN
INSELN
Poster, c. 1930
Designer: Koeke

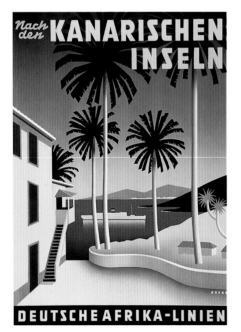

HAPAG
Poster, c. 1930
Designer: Otto Arpke

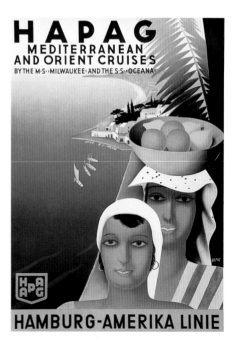

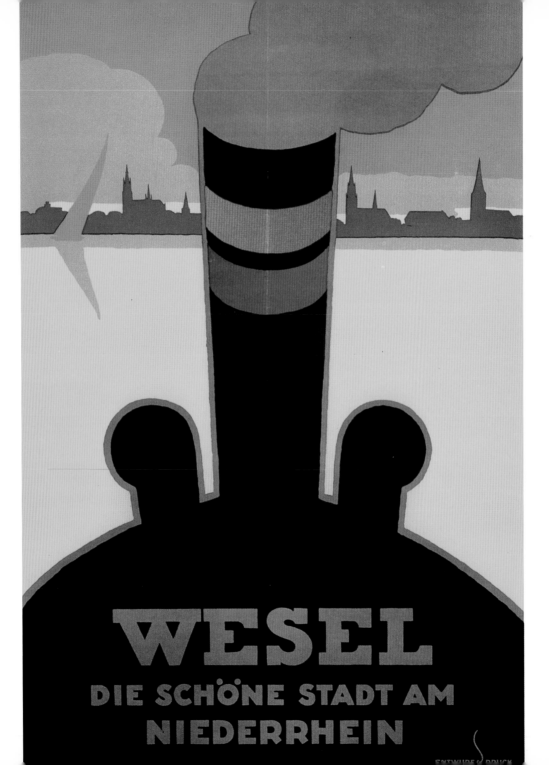

WESEL
Poster, c. 1925
Designer:
G. H. Heimig

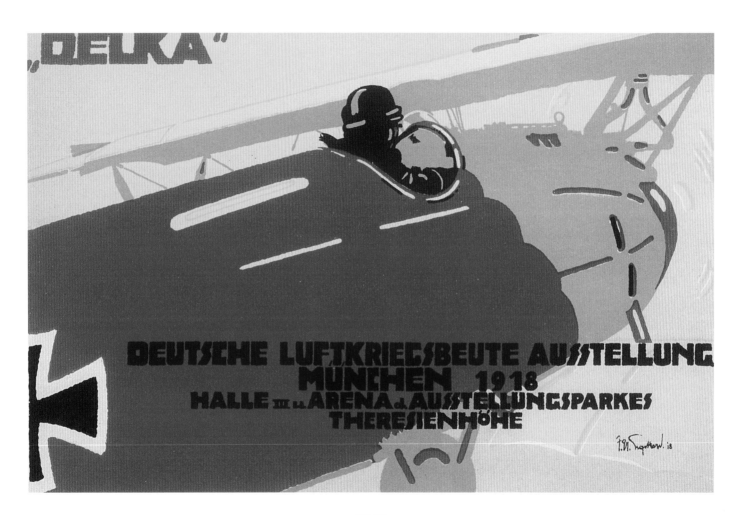

DELKA
Poster, 1918
Designer unknown

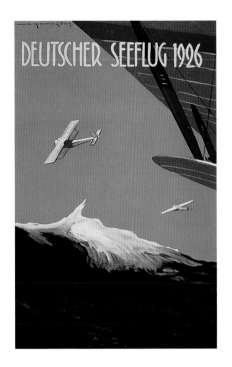

DEUTSCHER SEEFLUG
Poster, 1926
Designer: Walter Hemming

WINTER IN BAYERN
Poster, c. 1930
Designer: Walter Keimel

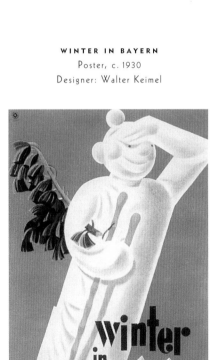

DEUTSCHE EISENBAHN
Poster, c. 1935
Designer: Schneider

Speed was an icon of the modern age, and getting from here to there or there to here was the theme of German transportation advertising. It did not matter by what means this was achieved—cars, trucks, trains, or bicycles. Perpetual motion was promoted through the conceit of the blur. Modern life was typified by quick passage. With barely a few stylistic tweaks and perhaps only a couple of motion lines, the *Gebrauchsgraphiker* could impart the impression of speed. In the Hirschbold poster (opposite page) the forward thrust of the racing automobile and truck is accentuated by the leaning buildings rendered in an expressionistic manner.

Objects were key to transportation advertising. The simulated motion lines of tire treads, for example, were emphasized as symbolic of speed. Even renderings of inanimate objects were graphically highlighted and positioned at angles in such a way as to suggest forward thrust. But, not every car, truck, or bike was presented in a state of motion. Cars were sold both as instruments of speed and as objects of elegance, as the poster for DUX (page 62) reveals. Brand names were also emphasized. The poster for Opel (page 63) doesn't even show the vehicle, only a somewhat haunting portrait of a driver; yet even this otherwise static image evokes a sense of anticipation that the driver will soon take off for points unknown. The advertisements shown here are surprisingly sophisticated compared to others in this genre, which could also be very literal and uninspired. The most unusual is the Mercedes poster (page 64) designed in the manner of the Bauhaus in which abstract visual elements barely hint at the real object.

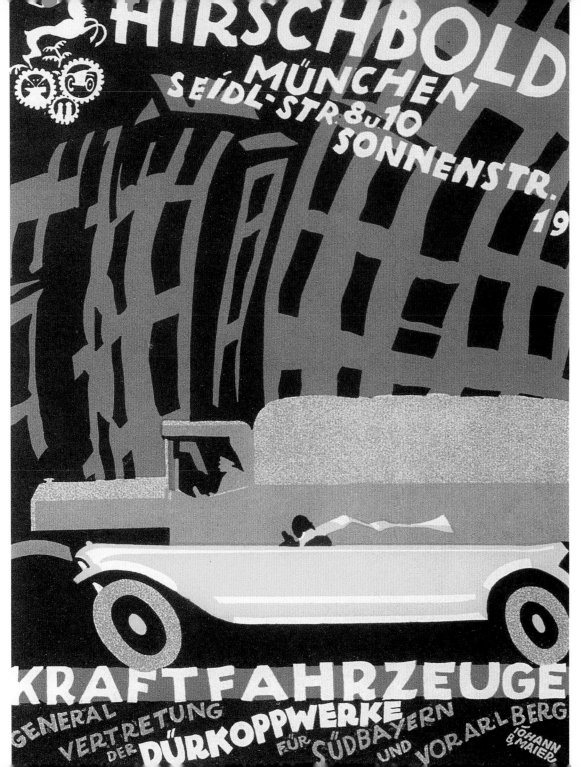

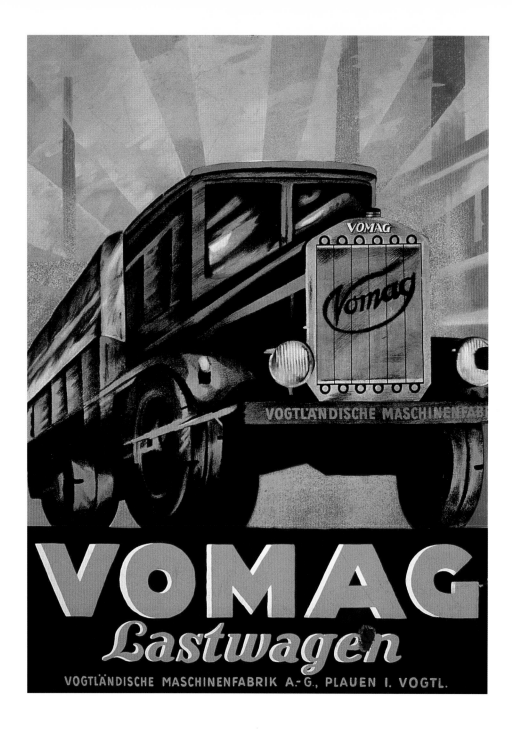

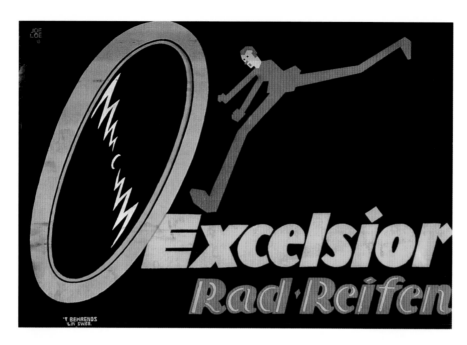

EXCELSIOR
Poster, c. 1922
Designer: T. Behrends

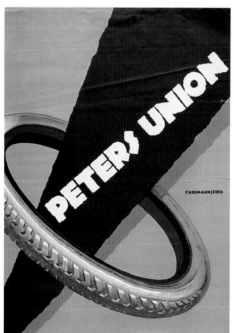

PETERS UNION
Poster, c. 1922
Designer:
F. Neumannsfred

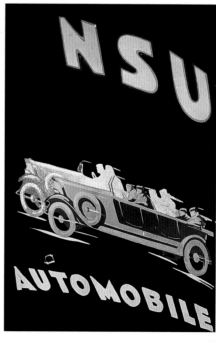

NSU
Enamel sign, 1925
Designer unknown

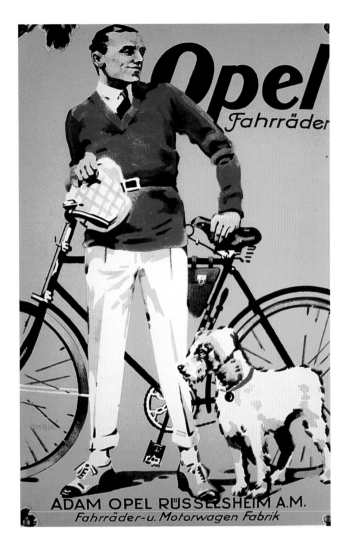

OPEL
Poster, c. 1925
Designer unknown

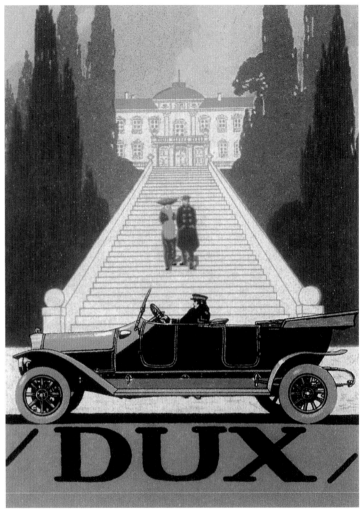

DUX
Poster, c. 1913
Designer unknown

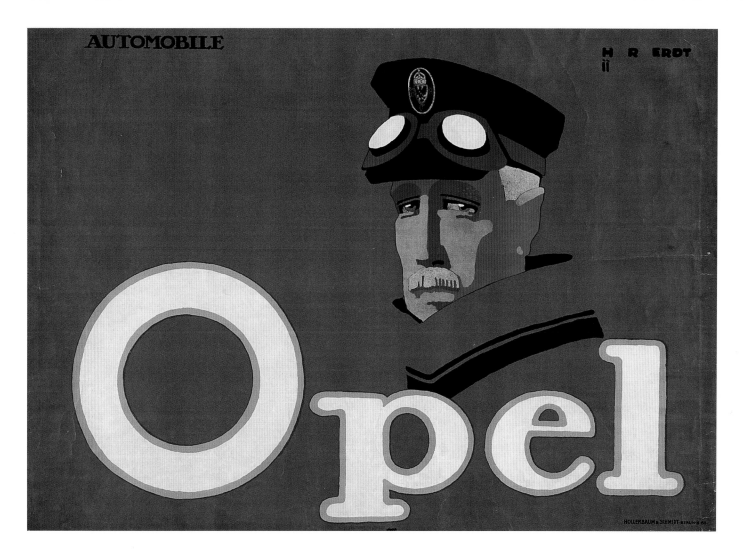

OPEL
Poster, c. 1914
Designer: H. R. Erdt

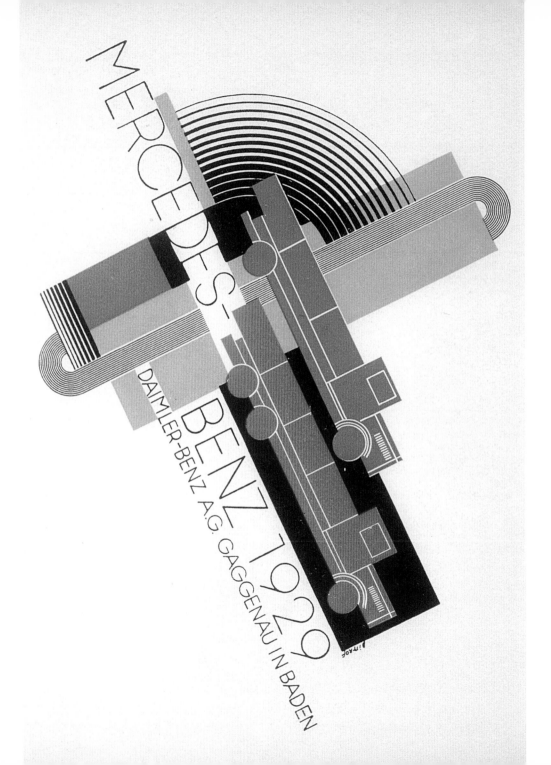

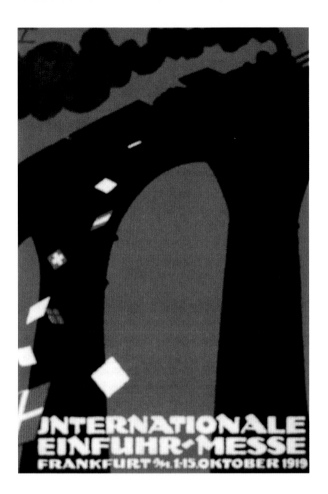

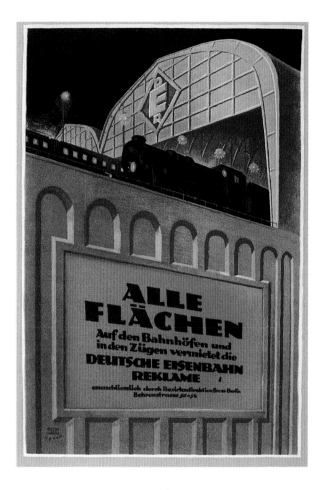

INTERNATIONALE
EINFUHR-MESSE
Poster, 1919
Designer: Ludwig
Hohlwein

ALLE FLÄCHEN
Poster, c. 1919
Designer: Lucian
Bernhard / Fritz Rosen

OPEL
Advertisement, 1927
Designer: Max Bittrof

"The new tempo of life has produced a vital change in the relations between buyers and sellers," wrote a critic in *Commercial Art 1927* about the nature of advertising displays found in shops throughout Germany. Demands on time no longer allowed the customer to browse the shelves for products leisurely. Advertising was needed to inform, but more importantly, to direct the consumer toward the target; products were no longer mere objects but destinations. Advertising cosmetics (the industry most promoted in Germany from 1925 to 1933 according to *Gebrauchsgraphik*), tooth-

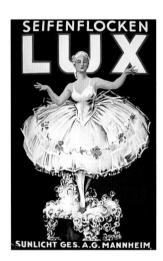

pastes, bath soaps, detergents, and other household items required more than developing an identity; it demanded designing signposts to the very spot in the store where the product would be found. The job of the commercial artist was to invent a character or motif that pointed the way. The man in the clean white shirt and the woman in the fresh white dress for Persil detergent (page 69) not only attract the eye, but point the way. More than in any other European advertising style, German *Werbekunst* set the standard for how the commonplace was monumentalized just enough to attract attention, but not so much that what was promoted discouraged the average consumer. Despite the hard sell of much German sundries advertising, humor was not entirely rejected, nor was elegance (depending on the purpose, of course). The advertisements for Syndetikon (page 72) are as witty as they are bold. The packages for Kramp & Comp body soaps (page 70–71) are as visually enticing as they are functional. Even if the focus of German advertising was on the product *über alles*, fine artistry was the driving force.

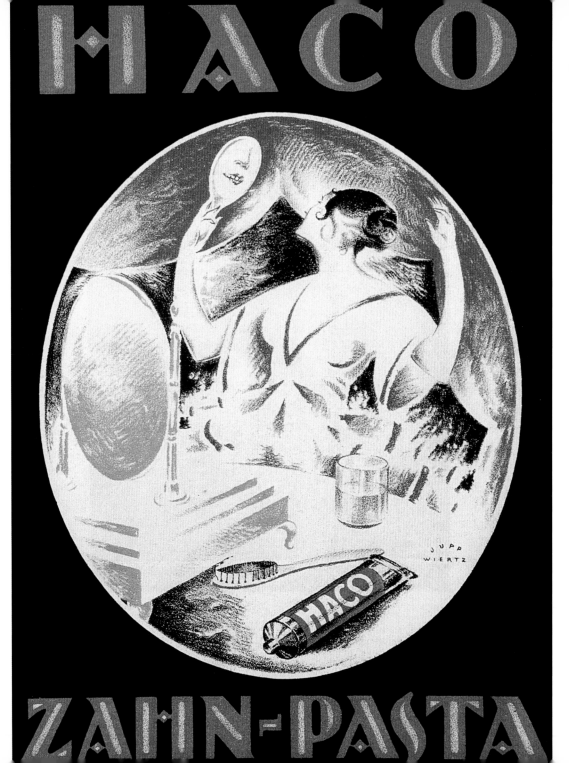

LUX
Enamel sign,
1925
Designer
unknown

HACO
ZAHN-PASTA
Poster, 1925
Designer:
Jupp Wiertz

Das neue Waschverfahren

Persil

Selbsttätiges
Waschmittel

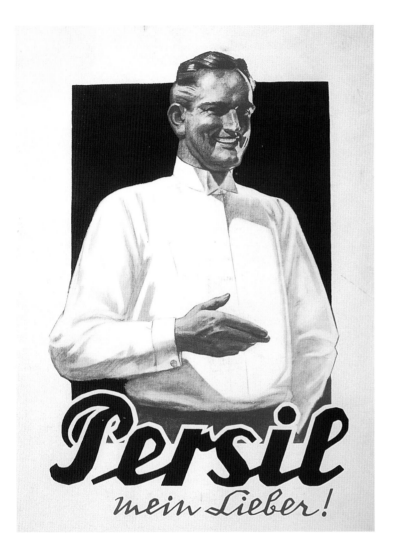

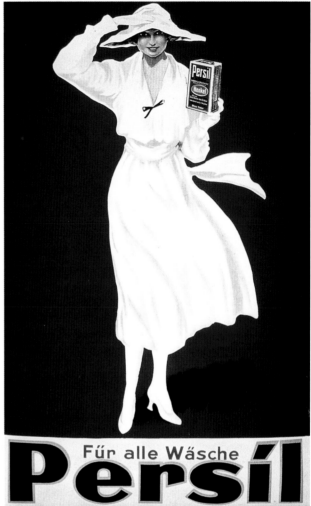

PERSIL

Point-of-purchase
sign, c. 1928
Designer unknown

PERSIL

Enamel sign, 1922
Designer: Kurt
Heilingstaedt

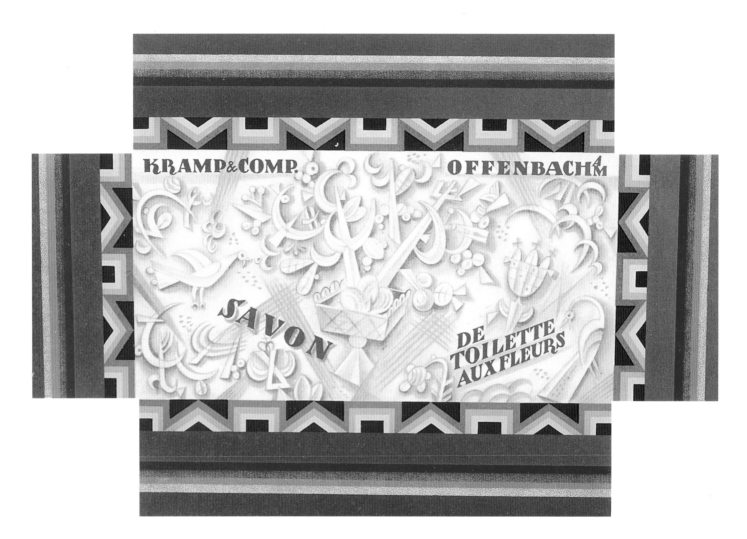

KRAMP & COMP
Soap package,
c. 1913
Designer unknown

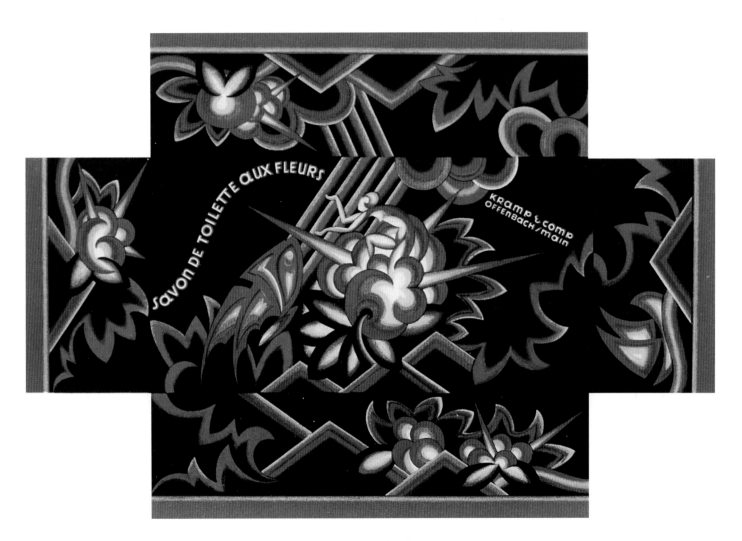

KRAMP & COMP
Soap package,
c. 1913
Designer unknown

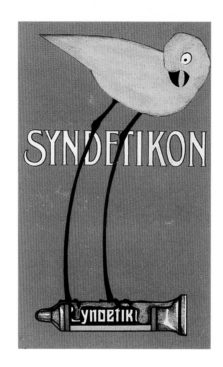

SYNDETIKON
Poster, c. 1914
Designer: Clara Ehmcke

SYNDETIKON
Poster, c. 1914
Designer: F. H. Ehmcke

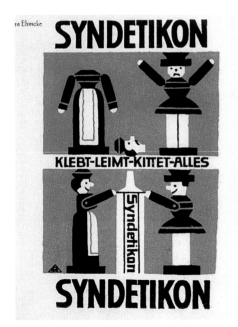

LUX
Poster, 1925
Designer
unknown

After schnitzel and strudel, Germany is best known for beer and chocolate. As exports, the latter brought in a steady stream of profit around the World War I era. As domestic special-ties, they were sought-after luxuries. The advertising and the packaging that promoted them were among the finest examples of an illustrative German commercial art. Confection shops were among the beneficiaries of beautifully designed point-of-purchase displays, and the boxes and tins were adorned with vibrant colors and stylish designs. Stollwerck (page 81) and Gartmann (this page and page 78) were among the leading manufacturers. Their ubiquitous pack-ages, posters, and enamel signs synthe-sized Art Nouveau and *art moderne* styles into distinctive identities. These specimens were truly graphic confec-tions. Beer was more conservatively promoted, but no less ubiquitous than the coffee, tea, and champagne (like Heinkel and Kupferberg Gold) adver-tising that filled the poster kiosks and shop windows in German cities, large and small. Many of the great German and Austrian poster artists contributed art and design to the wealth of advertising for food and drink, yet none was more prolific than Munich-based Ludwig Hohlwein (pages 75 and 76). *Hohlweinstil*, a stylized realism that made the commonplace romantic, eventually dominated German advertising. In 1906, a health food craze started in Germany, and Hohlwein was commissioned to create posters to promote "Alcohol Free Restaurants" and unprocessed foods. His skill at rendering made him the per-fect choice for representing the natural bounty that zealots hoped would convince Germans to embrace nutritional purity over heavily advertised packaged foodstuffs.

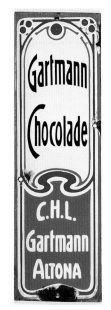

GARTMANN
CHOCOLADE
Enamel sign,
c. 1910
Designer unknown

MARCO-
POLO-TEE
Poster, 1915
Designer: Ludwig
Hohlwein

MARCO-POLO-TEE

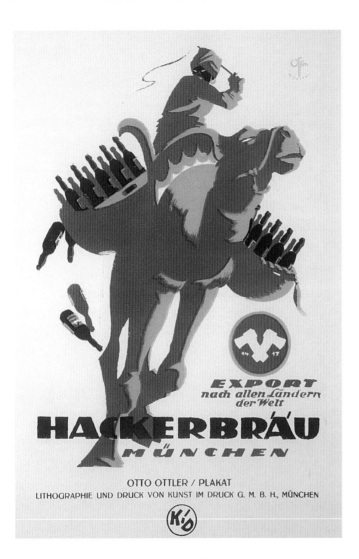

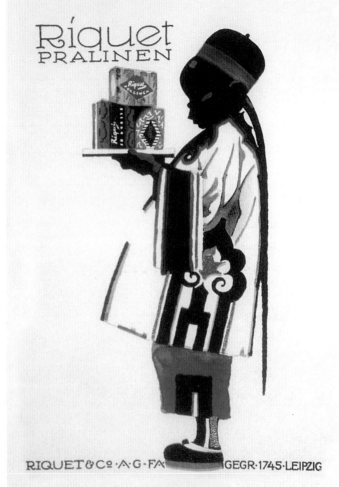

HACKERBRÄU
Poster, c. 1925
Designer: Otto Ottler

RIQUET PRALINEN
Poster, 1920
Designer: Ludwig
Hohlwein

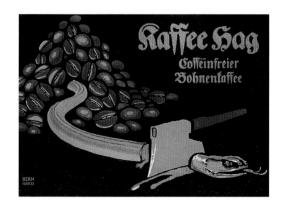

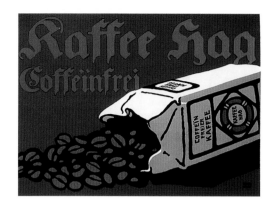

KAFFEE HAG
Poster, 1910
Designer: Lucian
Bernhard

KUPFERBERG GOLD
Poster, 1913
Designer: Julius
Gipkens

KAFFEE HAG
Poster, 1910
Designer: Lucian
Bernhard

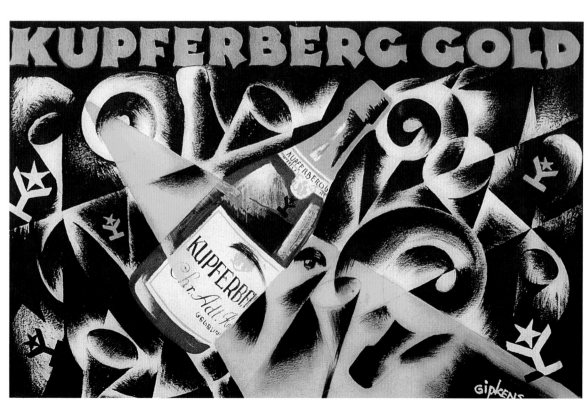

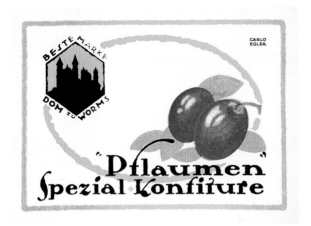

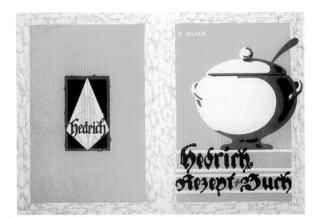

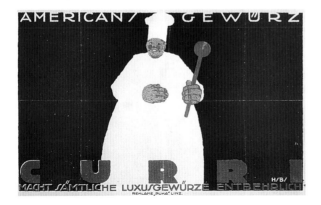

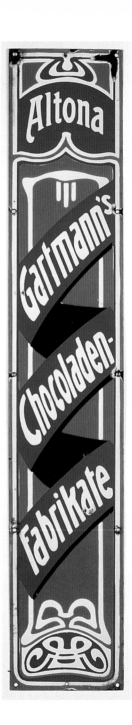

PFLAUMEN
Poster, c. 1913
Designer:
Carlo Egler

**GARTMANN'S
CHOCOLADEN-
FABRIKATE**
Enamel sign, c. 1910
Designer unknown

HEDRICH
Cookbook
jacket, c. 1913
Designer:
Carlo Egler

CURRI
Poster, c. 1922
Designer: "H/B"

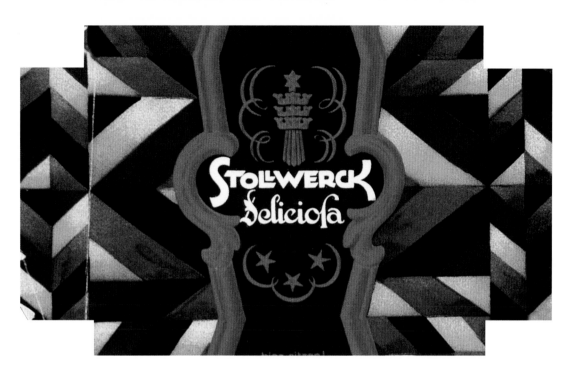

STOLLWERCK
Candy package,
c. 1913
Designer unkown

PLANTOX
Label, c. 1913
Designer: Wiertz

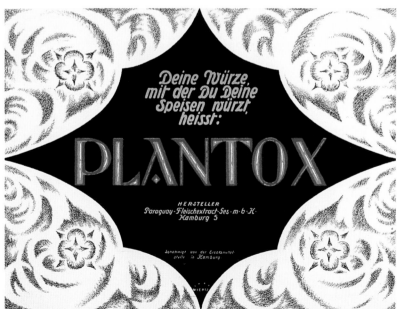

Smoke wafted through German society with a vengeance and smoking had developed its own culture and rituals. In 1933, *Gebrauchsgraphik* reported that in the previous ten years, since the period of great inflation, more advertising money was spent by the German tobacco industry than by any other, except the cosmetic industry. Daily consumption of tobacco resulted in huge demand and obscene profits, which in turn made massive advertising campaigns both necessary and affordable. The cigarette (and to a lesser extent, the cigar) was the quintessence of formal simplicity—and even beauty. Many brands produced aesthetically pleasing

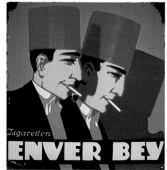

oval-shaped cigarettes that were packed in stylish tins. While some of these packages were elegantly classical—adorned only with a coat of arms or other heraldic device—others were given a modern appearance. Manoli's colorful package, designed by Lucian Bernhard, was branded with a simple M in a circle that prefigured the bullseye brand later affixed to Lucky Strike. In one of Bernhard's strongest *Sachplakat* images (page 86), a cigarette sits on the open Manoli box. Few other posters and advertisements come close to this for graphic eloquence or sales appeal. Other brands competed using a variety of visual tropes, including mascots (often well-dressed men or women, or exotic Turkish types). Identifiable logos were invaluable in promoting consumer awareness, and on occasion, humorous illustrations reinforced the serious hard sell. Fierce competition between brands with similar attributes allowed artists an opportunity to be imaginative. As long as the cigarette or cigar was represented in a flattering situation, emphasizing the fashionable nature of smoking, then the artist was given a long leash.

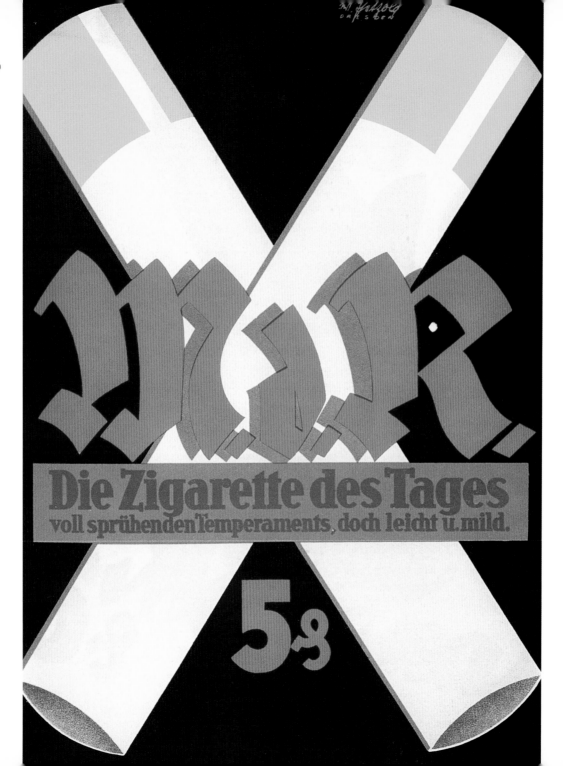

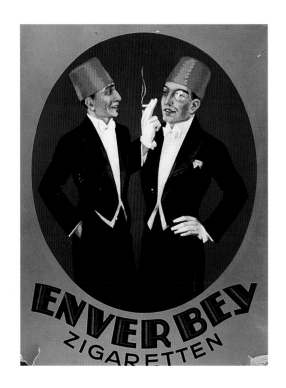

ENVER BEY
Point-of-purchase
display, c. 1926
Designer unknown

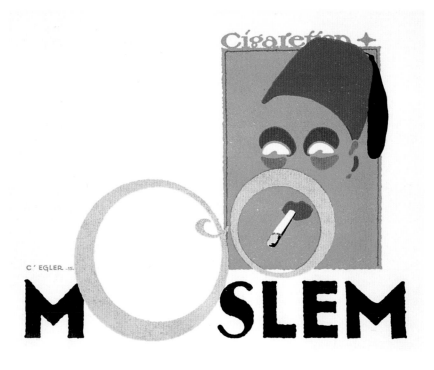

MOSLEM
Poster, 1914
Designer: Carlo Egler

PALM
Package, c. 1912
Designer: Carlo Egler

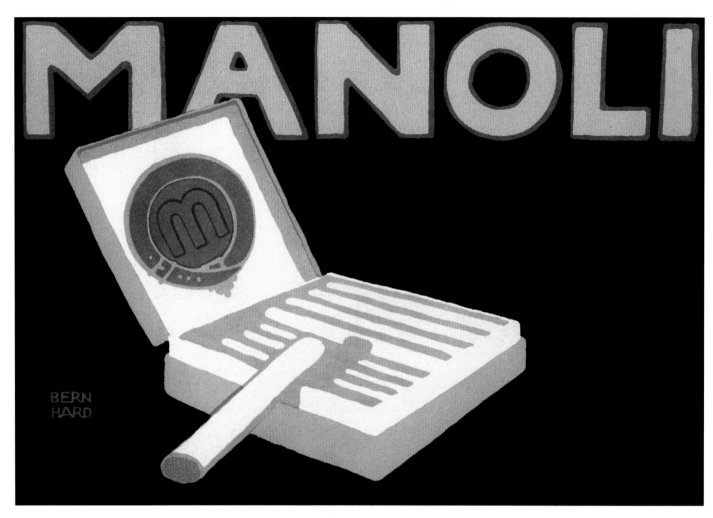

MANOLI
Poster, 1912
Designer: Lucian
Bernhard

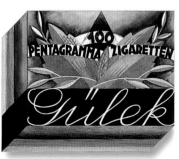

GÜLEK
Package, 1921
Designer:
Herbert Bayer

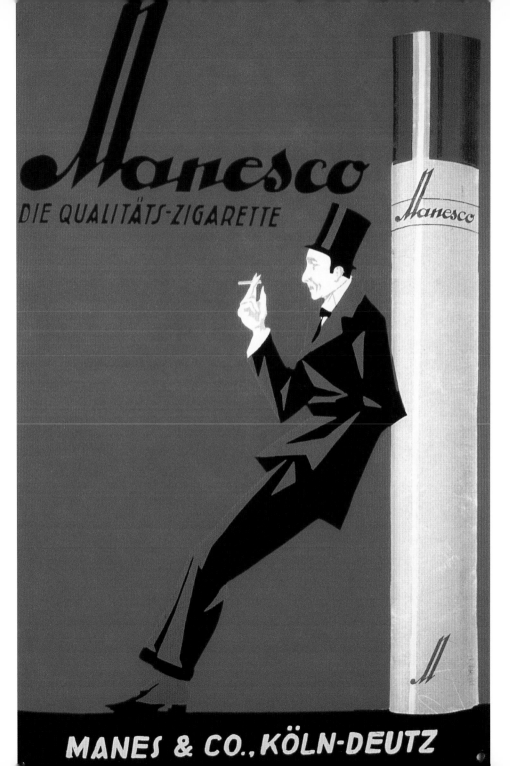

MANESCO
Enamel sign, c. 1925
Designer unknown

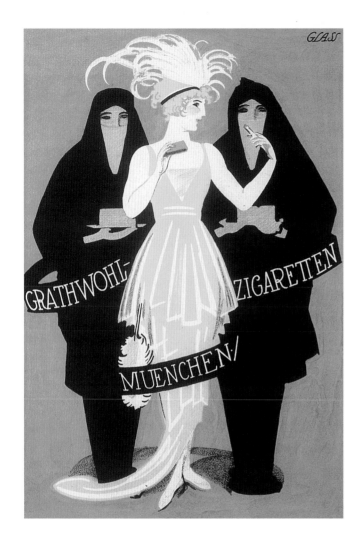

**GRATHWOHL-
ZIGARETTEN**
Poster, 1912
Designer: Franz
Paul Glass

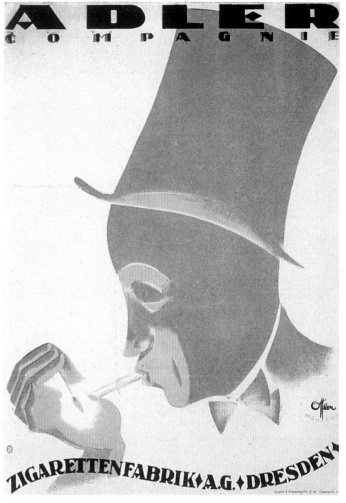

ADLER
Poster, c. 1922
Designer: Otto Ottler

"How can one describe those incredible times," wrote Stefan Lorant in "Sieg Heil," a history of Germany in the 1930s. "In the morning a newspaper cost 50,000 marks—in the evening, 100,000. The price of a single pair of shoelaces would have bought an entire shoestore with all its inventory a few weeks before. Beggars threw away 100,000-mark notes as they could buy nothing with them." Owing to Germany's immense war debt, the mark took such a dive that its value on the world market changed minute by minute. At the beginning of 1923, the American dollar was worth 7,424 marks. By August, the rate had risen to over a million; in November, the rate increased to 600 billion; and by December, it skyrocketed to 4,210,500,000,000. The thirty-five Reichsbank print-ing presses, working night and day, could not print new denominations fast enough to satisfy demand or keep up with inflation, so a flood of *Notgeld*, or emergency scrip, was issued daily by towns

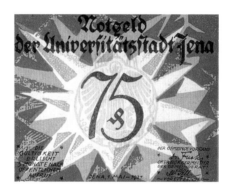

and businesses. Since official Reichsbank notes were virtually worthless, most emergency money was worth even less, save for an investment of faith; yet since they were used as instruments of barter, *Notgeld* notes were redeemable for goods or services. With the permission of the government, local and private institutions could print bills cheaply, usually on newspaper presses, on rag paper or cardboard. Since these printers were not standardized, the sizes, shapes, and designs were wildly inconsistent, and their images reflected the variety of talents and technology ranging from artful to primitive. Though many of the bills were beautifully rendered by professional artists and designers, others were scrawled by rank amateurs.

**DER
UNIVERSITÄTS-
STADT JENA**
Notgeld, 1921
Designer
unknown

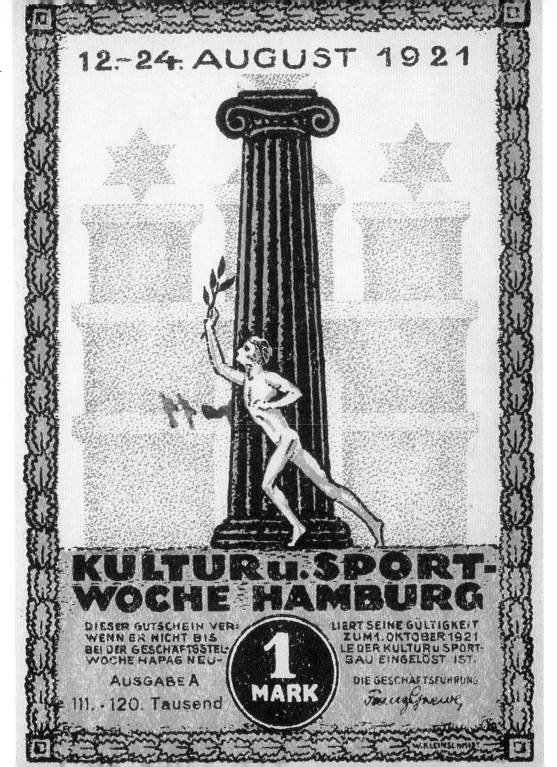

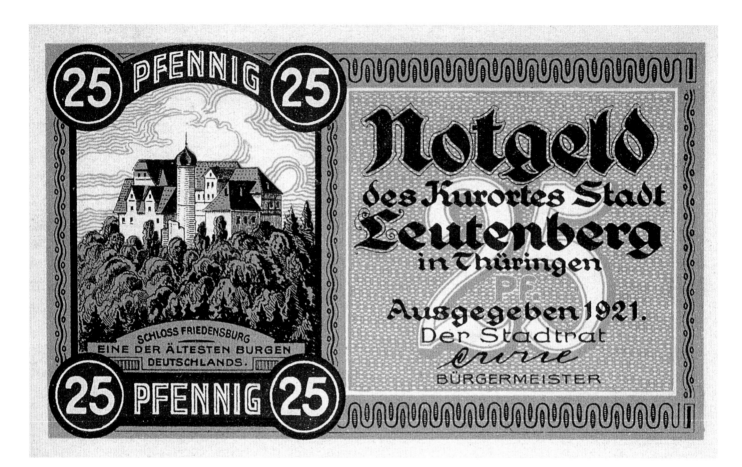

LEUTENBERG
Notgeld, 1921
Designer unknown

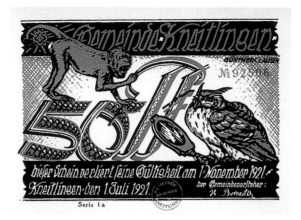

50 PFENNIG
Notgeld, 1921
Designer: Günther
Clausen

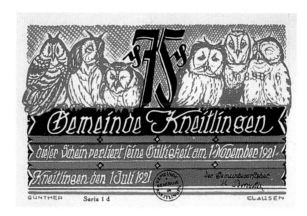

75 PFENNIG
Notgeld, 1921
Designer: Günther
Clausen

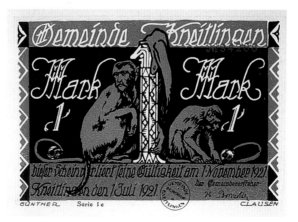

1 MARK
Notgeld, 1921
Designer: Günther
Clausen

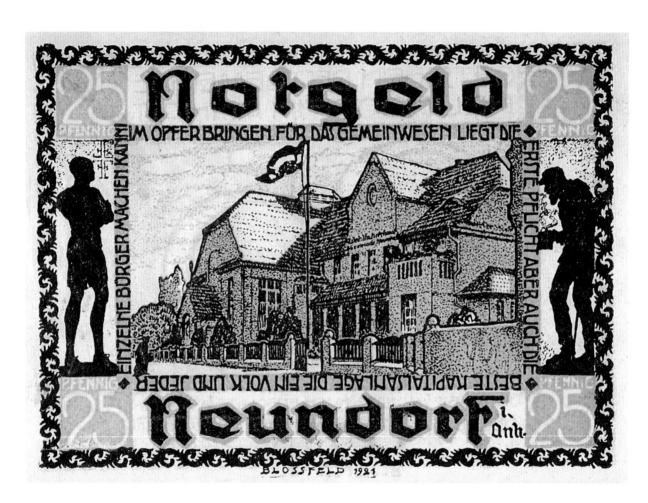

NEUNDORF
Notgeld, 1921
Designer: Blossfeld

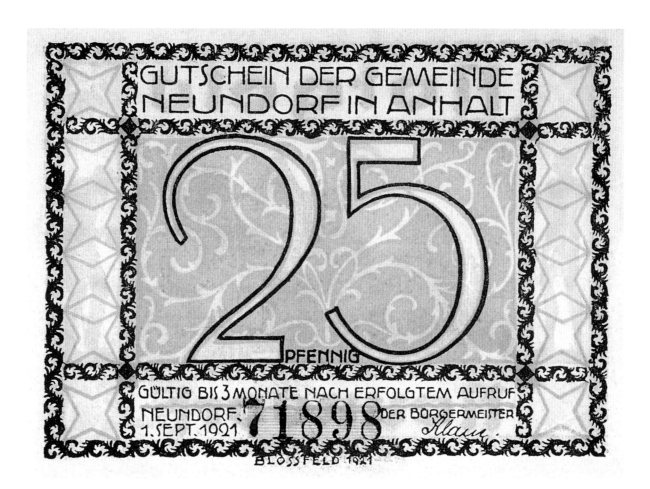

NEUNDORF
Notgeld, 1921
Designer: Blossfeld

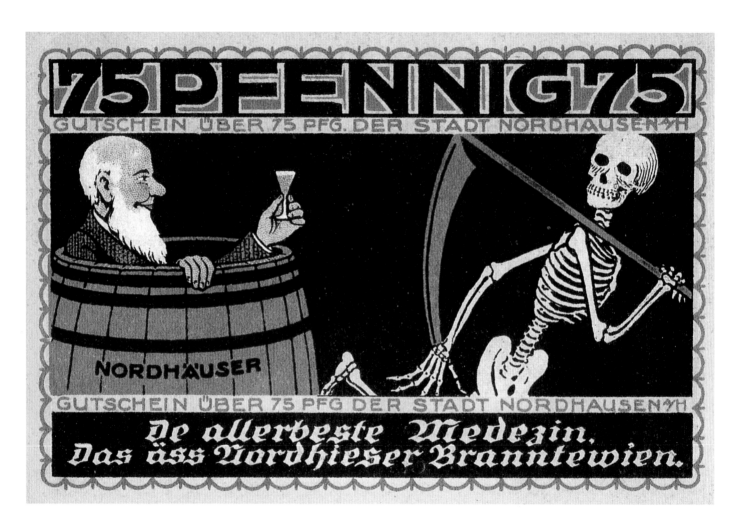

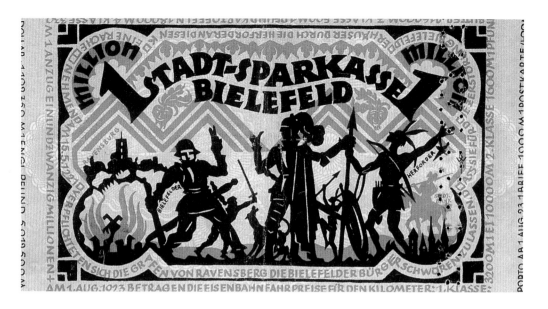

STADT-SPARKASSE
BIELEFELD
(front and back sides)
Notgeld, 1923
Designer: Herforder

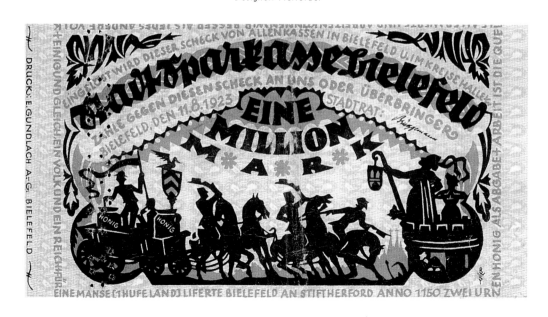

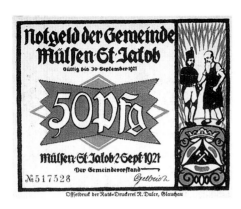

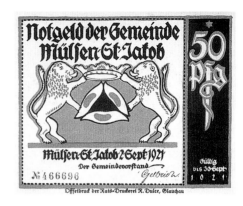

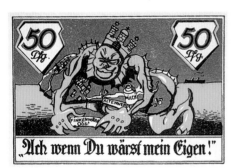

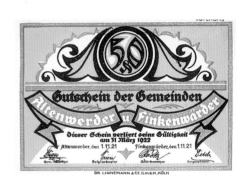

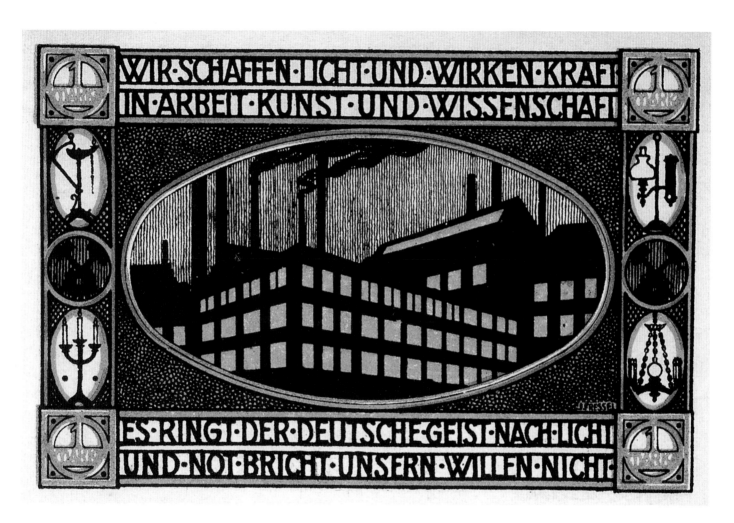

WIR SCHAFFEN
LICHT...
Notgeld, c. 1921
Designer: J. Fressel

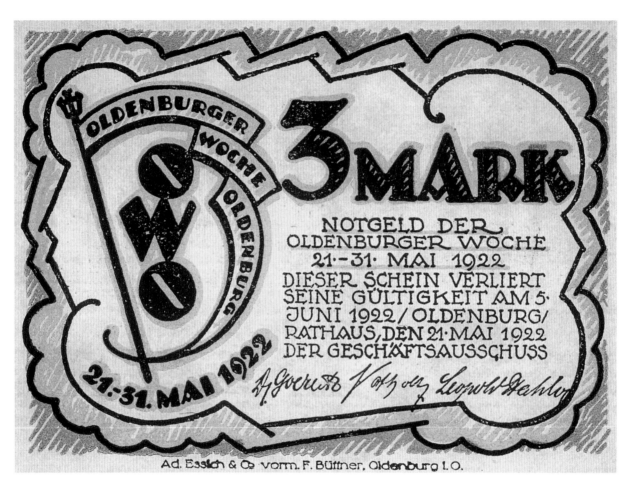

OLDENBURGER
WOCHE
Notgeld, 1922
Designer unknown

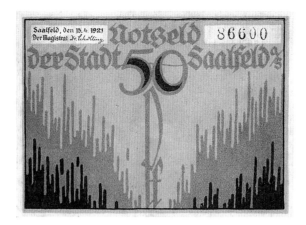

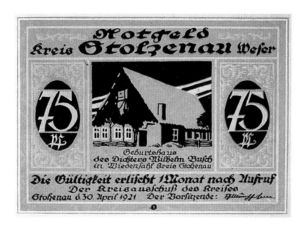

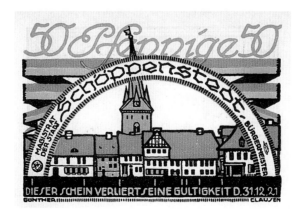

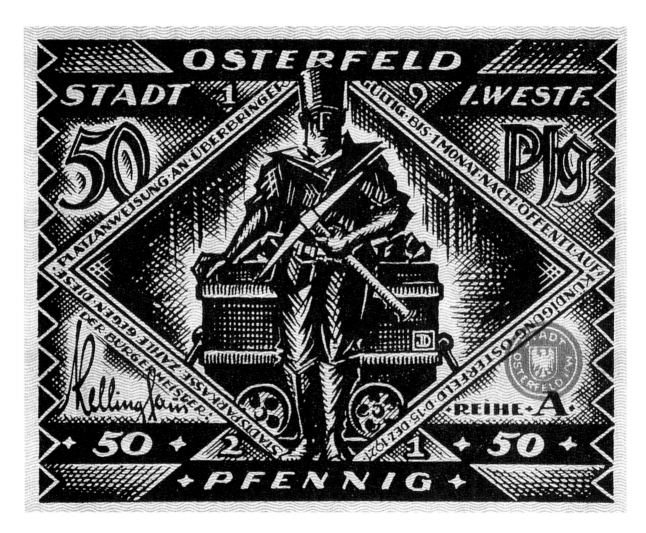

STADT OSTERFELD
Notgeld, 1921
Designer: Jos. Domnicus

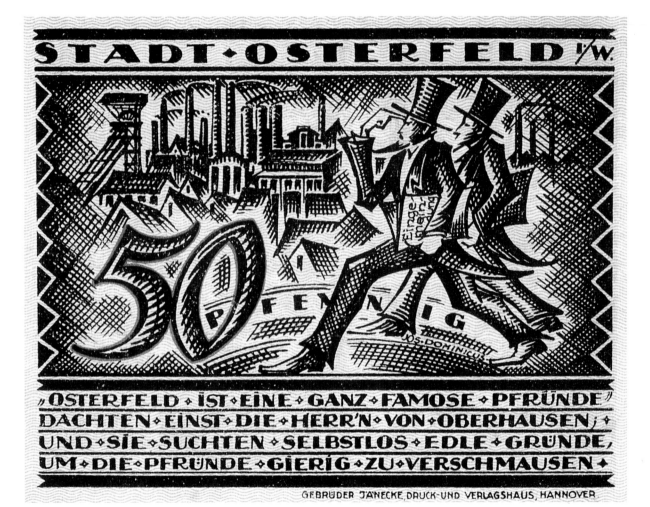

STADT OSTERFELD
Notgeld, 1921
Designer: Jos. Domnicus

50 PFENNIG
Notgeld, 1921
Designer: Rothschau

50 PFENNIG
Notgeld, 1921
Designer: Rothschau

25 PFENNIG
Notgeld, 1921
Designer unknown

50 PFENNIG
Notgeld, 1921
Designer: Nench

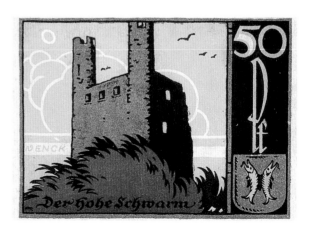

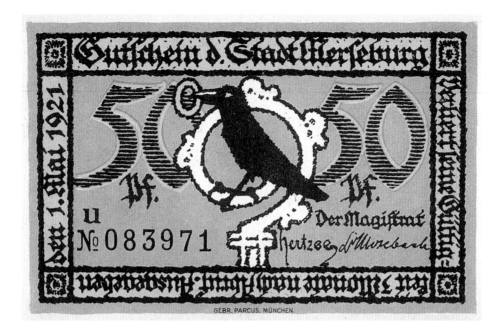

50 PFENNIG
Notgeld, 1921
Designer unknown

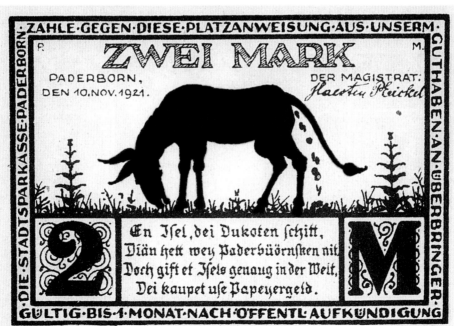

ZWEI MARK
Notgeld, 1921
Designer: "P.M."

Throughout Germany there were organizations representing nearly every business, cultural, and political activity. Not the least of these enterprises was commercial art, which, prior to World War I, emerged as a large industry that served industry. Such groups as the State Associations of Advertising Men, the Associations of Commercial Artists, and the Society of Trade Advertisers set standards, encouraged competition, and celebrated national artists. Most *Gebrauchgraphikers* belonged to one or more of these groups and took their roles as propagandists seriously. They attended the annual advertising and graphic arts fairs and congresses, and subscribed to the leading trade journals and association organs—including *Das Plakat*, *Gebrauchsgraphik*, and *Die Reklame*. From 1910 to 1921 *Das Plakat* was a lavish monthly journal comprised of numerous color tip-ins and inserts of original printed ephemera. The publication was designed both to whet the creative appetites of other artists and to induce business people to sample the unique

graphic styles available in Germany at that time. Between 1925 and 1941 *Gebrauchsgraphik* surveyed international advertising art, both moderne and modern. Its founding editor, F. K. Frenzel, was an astute observer and commentator on commercial art. He believed that advertising had beneficial effects for culture and society because it both taught the public about the world and provided good artistic models. Advertising was an integral part of German life. As these magazines testified, and the work presented vividly shows, creating the best advertising in Germany was a high calling.

**WEZEL
& NAUMANN**
Advertisement,
1921
Designer:
Kampmann

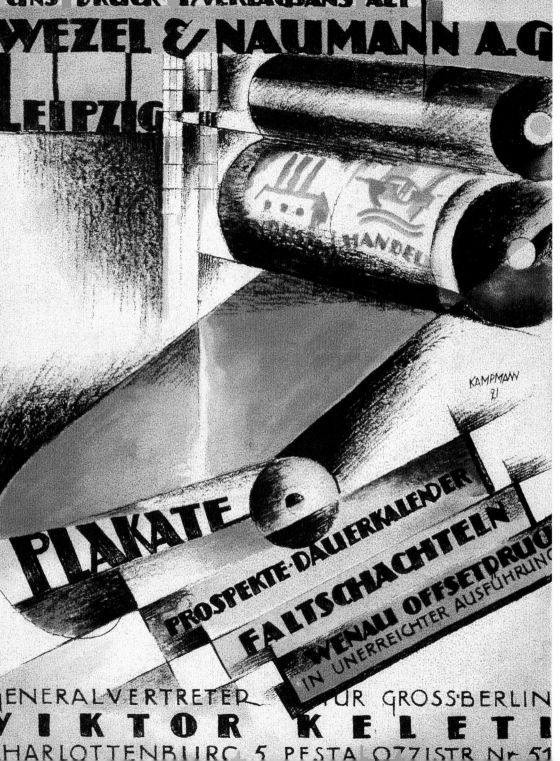

**EIN SPIEL
VON LICHT
UND SCHATTEN**
Advertisement,
1928
Designer unknown

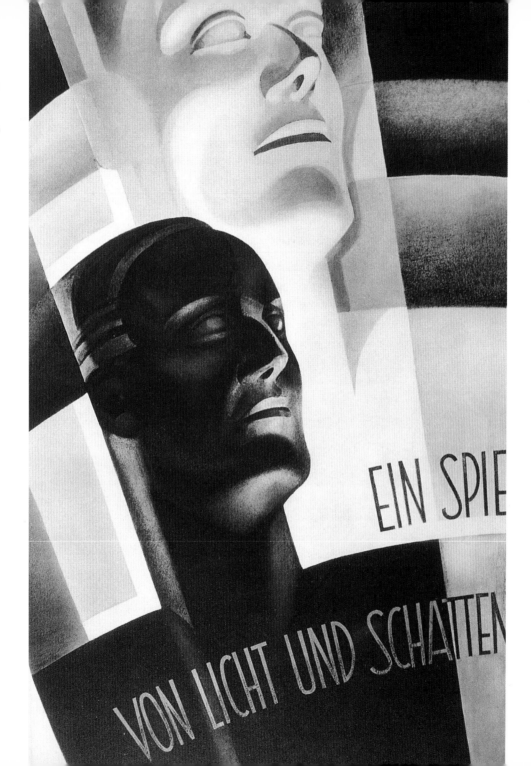

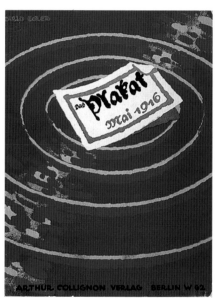

DAS PLAKAT
Magazine cover, 1916
Designer: Carlo Egler

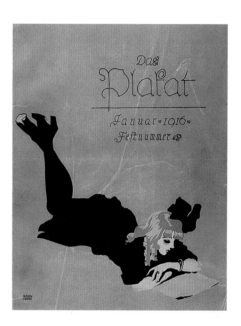

DAS PLAKAT
Magazine cover, 1916
Designer: Lucian Bernhard

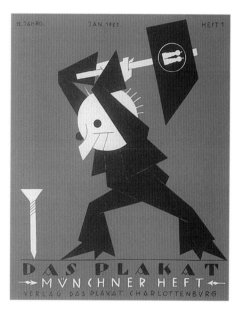

DAS PLAKAT
Magazine cover, 1921
Designer: W. Zietara

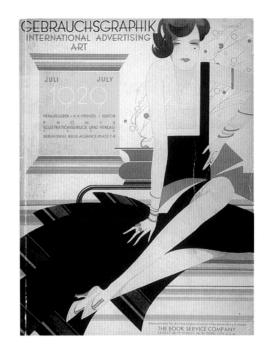

GEBRAUCHSGRAPHIK

Magazine cover, 1932

Designer: Trueb

GEBRAUCHSGRAPHIK

Magazine cover, 1927

Designer: Lucian

Bernhard/Fritz Rosen

GEBRAUCHSGRAPHIK

Magazine cover, 1939

Designer: Wiertz

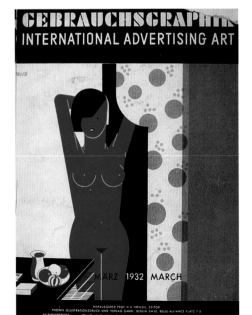

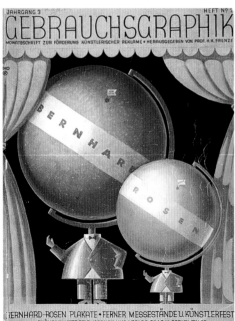

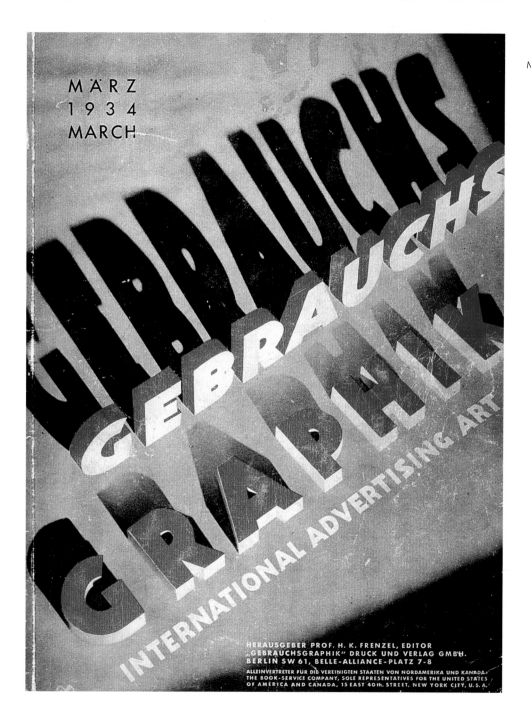

MÄRZ
1934
MARCH

GEBRAUCHS
GEBRAUCHS
GRAPHIK
INTERNATIONAL ADVERTISING ART

HERAUSGEBER PROF. H. K. FRENZEL, EDITOR
"GEBRAUCHSGRAPHIK" DRUCK UND VERLAG GMBH.
BERLIN SW 61, BELLE-ALLIANCE-PLATZ 7-8
ALLEINVERTRETER FÜR DIE VEREINIGTEN STAATEN VON NORDAMERIKA UND KANADA:
THE BOOK-SERVICE COMPANY, SOLE REPRESENTATIVES FOR THE UNITED STATES
OF AMERICA AND CANADA, 15 EAST 40th. STREET, NEW YORK CITY, U.S.A.

GEBRAUCHS-
GRAPHIK
Magazine cover, 1934
Designer unknown

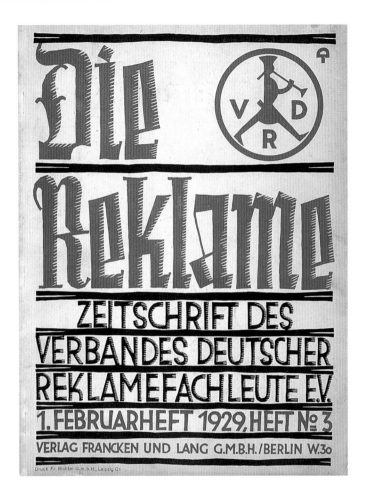

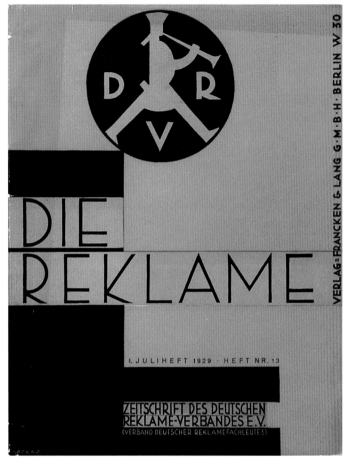

DIE REKLAME
Magazine cover, 1929
Designer unknown

DIE REKLAME
Magazine cover, 1929
Designer: Paul Pfund

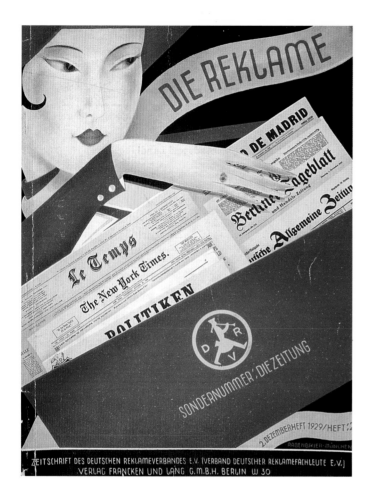

DIE REKLAME
Magazine cover, 1929
Designer: Rabenbauer

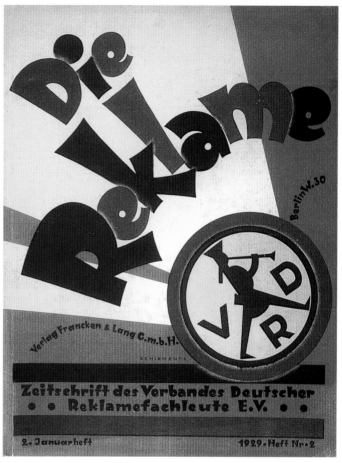

DIE REKLAME
Magazine cover, 1929
Designer: Schiementz

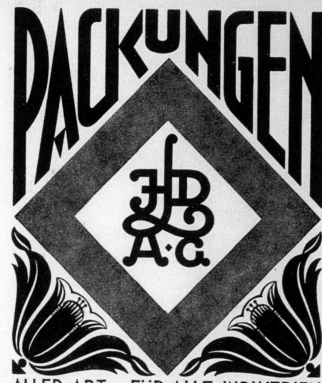

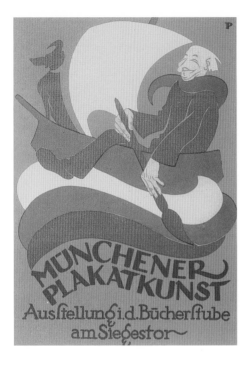

MÜNCHENER PLAKATKUNST
Poster, c. 1913
Designer: Emil
Preetorius

MIMOSA
Advertisement, c. 1923
Designer: Lucian
Bernhard / Fritz Rosen

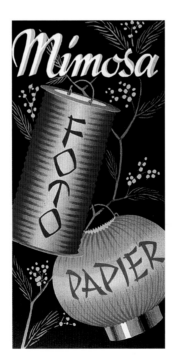

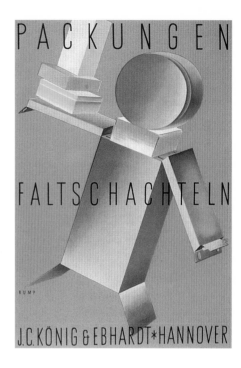

PACKUNGEN
Advertisement, 1925
Designer: Rump

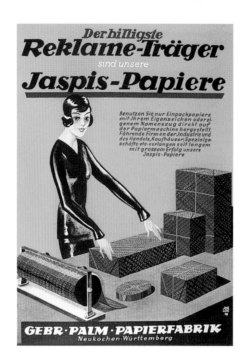

QUACK & FISCHER
Advertisement, c. 1928
Designer unknown

REKLAME-TRÄGER
Advertisement, 1928
Designer: Joe Loe

**GUNDLACH-
PACKUNGEN**
Advertisement, c. 1925
Designer: Otto Arpke

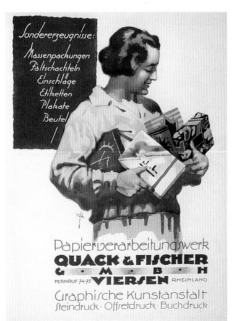

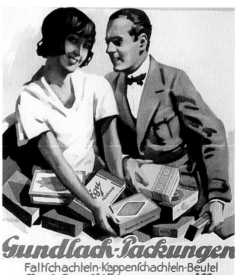

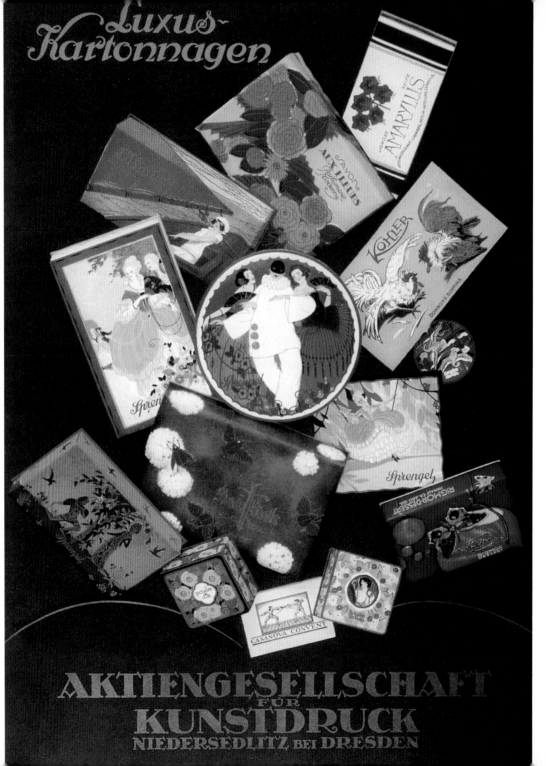

AKTIEN-
GESELLSCHAFT
FÜR KUNSTDRUCK
Advertisement, 1925
Designer unknown

The Gothic typeface generally known as Fraktur is a spikey, medieval black letter that is as hard to read as it is ugly, but it was long held up as the German national typeface. Despite numerous attempts to aestheticize the basic form, progressive typographers believed that it was the essence of typographic tyranny. Early signs of revolution began with the advent in the late nineteenth century of *Judgenstil*-inspired typefaces, which replaced the sharp spikes with sinuous curves. When *Sachplakat* emerged, Fraktur was replaced by stark block lettering, often drawn by hand. While the spirit of this block lettering was Germanic, it was decidedly modern in appearance. It was also more eclectic, with swashes, ligatures, scripts, and other decorative tropes added on. Block lettering shared the stage with Expressionist-influenced woodcut rendered forms that were primitive and often unwieldy. By the 1920s, the demand in advertising for the *art moderne* sensibility in type forced the leading German foundries—Bauer, Flinsch, Stempel, and Berthold—to issue more formal, though no less quirky, alphabets adapted from letterforms designed by leading German poster artists. These type families

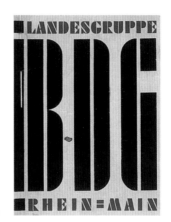

were promoted through ostentatious specimen sheets to commercial artists throughout Germany. At the same time, a progressive typographic movement was emerging at the Bauhaus and under the banner of *Neue Typographie*, a new typographic method that favored assymetrical layout and sans-serif typefaces. Chief proselytizer Jan Tschicold's doctrine of asymmetry literally stood type on its side. The New Typography broke conventions and eliminated all ornament in favor of stark geometric forms—rectangles, circles, and squares.

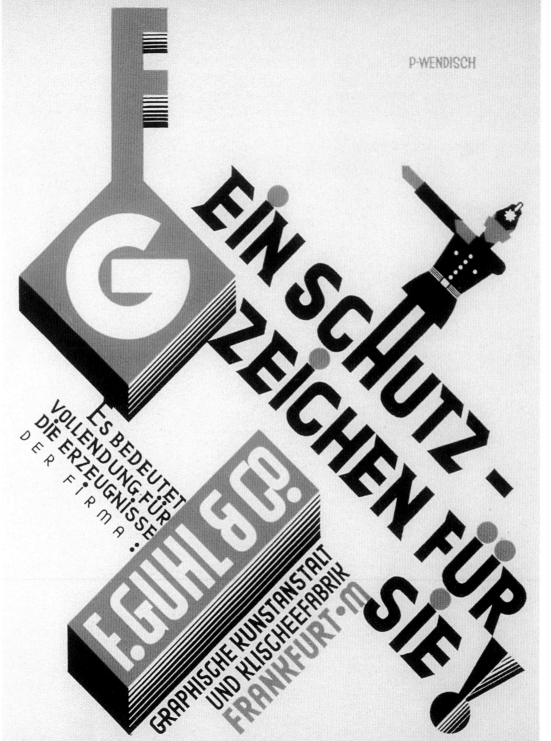

P-WENDISCH

EIN SCHUTZ-ZEICHEN FÜR SIE!

ES BEDEUTET VOLLENDUNG FÜR DIE ERZEUGNISSE DER FIRMA

F. GUHL & CO.

GRAPHISCHE KUNSTANSTALT UND KLISCHEEFABRIK FRANKFURT·M

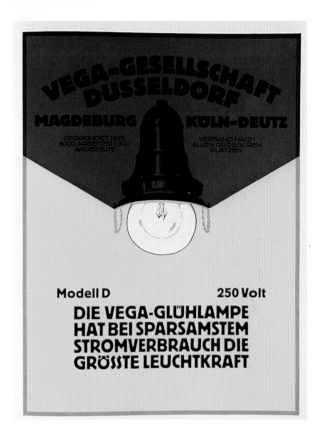

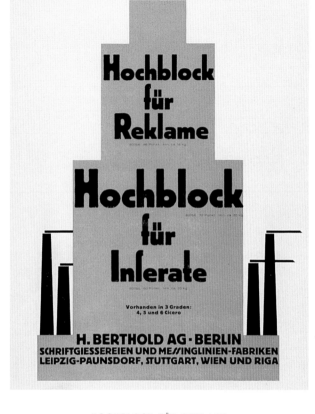

VEGA-GESELLSCHAFT
Advertisement, 1920
Designer: Louis Oppenheim

HOCHBLOCK FÜR REKLAME
Type specimen, 1920
Designer: Louis Oppenheim

L. KRUSZYNSKI
Letterhead, 1923
Designer unknown

(opposite)
LUDWIG FLATAU
Letterheads, 1927
Designer: Paul Pfund

AUTORISIERTE OPEL-VERTRETUNG
GENERAL-VERTRETUNG ERNST MAG
FÜR BERLIN UND PROVINZ BRANDENBURG

LUDWIG FLATAU

AUTOMOBILE · MOTORRÄDER · WASSERFAHRZEUGE
REPARATURWERKSTATT · ZUBEHÖR ·
ERSATZTEILLAGER · TANKSTELLE

FERNSPR. WESTEND 2253
BERLIN-
CHARLOTTENBURG 5
KAISERDAMM 105

INTERNATIONALE MONATSHEFTE FÜR BAUKUNST · RAUMKUNST · WERKKUNST

DIE PYRAMIDE

SIEBEN STÄBE · VERLAGS- UND DRUCKEREI-GESELLSCHAFT M · B · H · BERLIN-ZEHLENDORF

FERNSPR. ZEHLENDORF
NR. 3007 · POSTSCHECK-
KONTO = BERLIN 33607

BANK-KONTO = DARMSTÄDTER
U. NATIONALBANK, FILIALE
BERLIN-LICHTERFELDE · W.

KONRAD BEICHT
ARCHITEKT B · D · A

HOCHBAU UND INNENAUSSTATTUNG
BANK = DRESDNER BANK, FILIALE LIEGNITZ
POSTSCHECK-KONTO = BRESLAU NR. 35073
BÜRO UND WOHNUNG = FERNSPRECHER 3225
ATELIER = FERNSPRECHER 3225

DIE FORM
Magazine
cover, 1924
Designer:
Joost Schmidt

DIE FORM

ZEITSCHRIFT FÜR GESTALTENDE ARBEIT

VERLAG HERMANN RECKENDORF, BERLIN W35

JULI	:	1926
HEFT	:	10
JAHRGANG :		I

STERNDROGERIE HERZBERG

INHABER: APOTHEKER MAXIMILIAN SONTHEIMER UND FERDINAND FISCHER

★ STÄNDIGES LAGER WISSENSCHAFTLICH GEPRÜFTER ARTIKEL ★ ERSTKLASSIGE ABTEILUNG FÜR LIEBHABER-PHOTOGRAPHIE ★
ZUR SCHÖNHEITS-, GESUNDHEITS- UND KRANKEN-PFLEGE ENTWICKELN UND KOPIEREN VON EINGESANDTEN PLATTEN

LABORATORIUM FÜR PHARMAZEUTISCHE UND KOSMETISCHE PRÄPARATE

KONTOR UND GESCHÄFTSRÄUME: AM MARKT 25
FERNSPRECHER 148

CURT BEREND SCHEIBENBERG

MUSIK
INSTRUMENTE
VERSAND
FABRIK

POSTSCHECK-VERKEHR:
PLAUEN (VOGTLAND) 286
BANK-KONTO: BÜRO DER
SACHSEN-BANK PLAUEN

FERNSPRECHER 356, 384
TELEGRAMM-ANSCHRIFT:
MUSIKA, SCHEIBENBERG
UNIVERSAL MINING CODE

✦

HANSI REICHARDS BERLIN + NÜRNBERG + MANNHEIM
HANNOVER + MAGDEBURG + WIEN

TELEGR.-ADRESSE
SCHAUSPIELBÜRO **SCHAUSPIELAGENTUREN**

VERMITTELUNGEN NACH ALLEN PLÄTZEN DER WELT + 1. INTERNATIONALES THEATER-AUSKUNFTSBÜRO

STERNDROGERIE
HERZBERG
Letterhead, 1924
Designer unknown

CURT BEREND
SCHEIBENBERG
Letterhead, 1924
Designer unknown

HANSI
REICHARDS
Letterhead, 1924
Designer unknown

**HOHENZOLLERN
KUNSTGEWERBEHAUS**
Letterhead, c. 1913
Designer: F. H. Ehmcke

ERNST MARX
Letterhead, c. 1913
Designer: F. H. Ehmcke

RICH & RUHNAY
Letterhead, 1924
Designer: Heinz Weber

**TYPOGRAPHISCHE
MITTEILUNGEN**
Magazine
cover, 1923
Designer unknown

UNTITLED
Alphabet, 1925
Designer: Otto Heim

ABCDEFG

MNOPQR

abcdefghi

rstuvwxyz

TANGO ITALIC
Alphabet, c. 1922
Designer: E. Deutsch

JOH. HARTLEIB
Letterhead, 1919
Designer unknown

abcdefghijklmno
pqrſstuvwxyz
ABCDEFGHIJKLMN
OPQRSTUVWXYZ

STENCIL
Alphabet, c. 1928
Designer: Joseph
Albers

K. ZIMMERMANN
Letterhead, 1919
Designer unknown

abcdefghijklm
nopqrstuvwxyz
ABCDEFGHIJKL
MNOPQRSTUV

JOH. HARTLEIB
Letterhead, 1919
Designer unknown

XYLO
Alphabet, c. 1927
Designer: Benjamin
Krebs

IMPORT COMPANY
Letterhead, 1919
Designer unknown

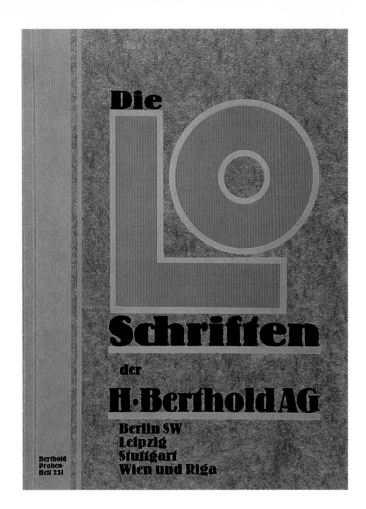

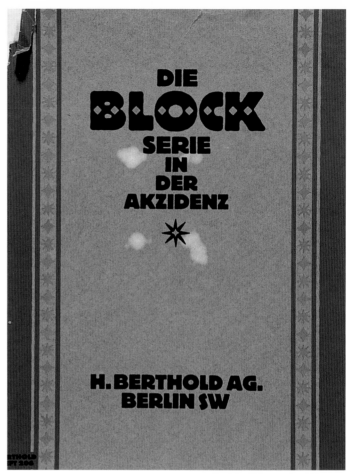

DIE LO SCHRIFTEN
Type specimen, 1920
Designer: Louis Oppenheim

DIE BLOCK
SERIE IN DER AKZIDENZ
Type specimen, 1920
Designer: Louis Oppenheim

KINO
Advertising stamp, 1913
Designer unknown

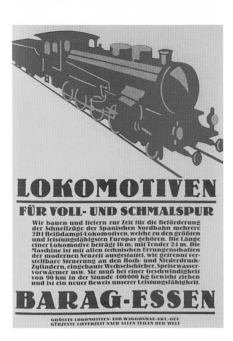

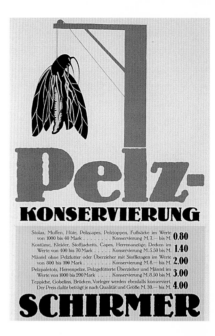

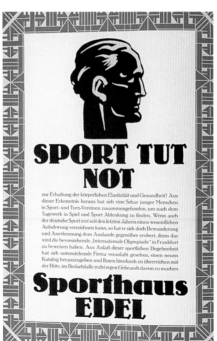

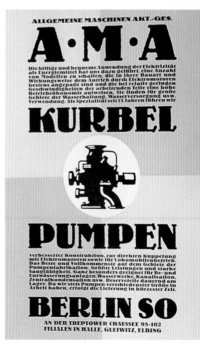

BIBLIOGRAPHY

Ades, Dawn. *The 20th-Century Poster: Design of the Avant Garde.* Minneapolis: Walker Art Center; New York: Abbeville Press, 1987.

Busch, Hugo und H. Cossmann. *Kunst Schrift und Schrift Kunst.* Düsseldorf: B. Kühlenkunst und Verlagsanstalt, 1927.

Commercial Art. Volume II. London: The Studio Limited, 1927.

Commercial Art. Volume III. London: The Studio Limited, 1927.

Frenzel, H. K. "Brief Remarks on Pictorial Form in Advertising." In *Gebrauchsgraphik #5.* Berlin, 1928.

Lorant, Stefan. *Sieg Heil! An Illustrated History of Germany from Bismarck to Hitler.* New York: W. W. Norton, 1974.

Plakat Gedanke und Kunst. Stuttgart: Propaganda Stuttgart, 1922.

Sachs, Hans. "The Artistic and Ideal Value of a Collection of Posters." In *Gebrauchsgraphik #11.* Berlin, 1930.

Smith, Virginia. *The Funny Little Man: The Biography of a Graphic Image.* New York: Van Nostrand Rinehold, 1993.

von zur Westen, Walter. *Reklama und Kunst.* Bielefeld und Leipzig: Verlag von Velhangen und Klasing, 1914.

Weill, Alain. *Plakatkunst International.* Berlin: Frölich & Kauffmann, 1985.

Wingler, Hans. *The Bauhaus: Weimar, Dessau, Berlin, Chicago.* Cambridge: The MIT Press, 1969.